£16.50

£10.55

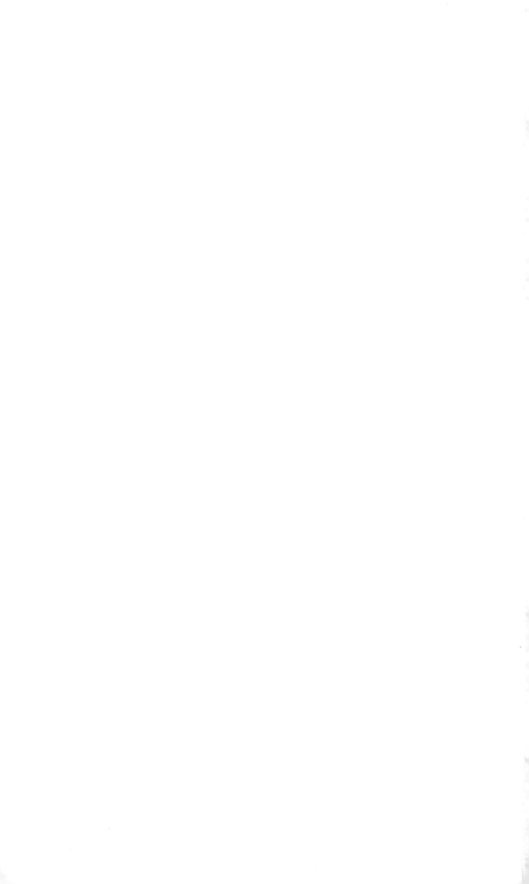

Two Chinese Treatises on Calligraphy

宋姜白石書

蘭亭真蹟隱臨本行于世臨本少石本行
于世石本難定武本行于世何逮之記云石軍
書此時乃有神助及醒後它日更書數十百
本終無祓禊兩書石軍亦自珍愛此書付子
孫傳寶至七代孫智永禪師永付弟子辯
才大宗求之不得乃遣監察御史蕭翼以
計求之大宗殂殉葬昭陵及唐末溫韜盜發
魏哥以未詣貿墨瀋流洛人間外
蘭亭真蹟⋯⋯

此真蹟之本末也

Two Chinese Treatises on Calligraphy

Treatise on Calligraphy (Shu pu)
Sun Qianli

Sequel to the "Treatise on Calligraphy" (Xu shu pu)
Jiang Kui

Introduced, translated, and annotated by
Chang Ch'ung-ho and Hans H. Frankel

Yale University Press
New Haven & London

Frontispiece: Calligraphy attributed to Jiang Kui.

Designed by Deborah Dutton.
Set in Joanna Monotype by Asco Trade Typesetting Ltd., Hong Kong.

Printed in the United States of America by Edwards Brothers, Inc., Ann Arbor, Michigan.

Library of Congress Cataloging-in-Publication Data
Two Chinese treatises on calligraphy/introduced, translated, and
 annotated by Chang Ch'ung-ho and Hans H. Frankel.
 p. cm.
 'Treatise on calligraphy (Shu pu) [by] Sun Qianli; Sequel to the
 "Treatise on calligraphy" (Xu Shu pu) [by] Jiang Kui.'
 Includes bibliographical references and index.
 ISBN 0-300-06118-8 (acid-free)
 1. Calligraphy, Chinese—History—T'ang–Five dynasties, 618–960.
 2. Chinese language—Cursive writing. 3. Calligraphy, Chinese.
 I. Chang, Ch'ung-ho. II. Frankel, Hans (Hans Hermann), 1916–
 III. Sun, Kuo-t'ing, 648–703. Shu p'u. English. IV. Chiang,
 K'uei, ca. 1155–1235. Hsü Shu p'u. English.
 NK3634.A4C8785 1995
 745.6'19951—dc20 95-268

A catalogue record for this book is available from the British Library.

The paper in this book meets the guidelines for permanence and durability of the Committee on Production Guidelines for Book Longevity of the Council on Library Resources.

10 9 8 7 6 5 4 3 2 1

Contents

Acknowledgments

We would like to thank, first of all, Mary Gardner Neill. She has gone over every sentence of the two Chinese texts and the translations, and from our discussions with her have come countless improvements of our rendition. Much help has also been received from Fu Shen at the Freer Gallery in Washington, D.C., and from Richard Barnhart and Bai Qianshen at Yale. In Beijing in 1993 we received valuable information, especially on Jiang Kui, from Wang Shiqing and Liu Jin'an.

Among publications on Sun Qianli's Shu pu, we found Zhu Jianxin's richly annotated edition and Roger Goepper's erudite and thorough monograph most useful. For Jiang Kui's Xu shu pu we benefited especially from Lin Shuen-fu's three studies on the author. Without the splendid resources of the Yale University libraries, this work could never have been carried to completion.

For permission to reproduce the original Shu pu scroll, we wish to thank the owner, the National Palace Museum in Taipei, Taiwan. For reproduction we have used the copy of the scroll in the publication of Shu pu by the Palace Museum (Peiping, 1938).

We are indebted to Mary Pasti of Yale University Press for her superb editing, which has improved the manuscript in countless places.

Introduction

Calligraphy has consistently occupied a preeminent place among the visual arts in China. Artists, scholars, and critics have elevated it to a high level of sophistication, unique in the history of world civilization. To be sure, China is not the only country in which calligraphy developed as a fine art. Beautiful calligraphy may also be found, for example, in the illuminated manuscripts of medieval Europe and in the writings of Arabs and other Islamic peoples who adopted the Arabic script. But the number of elements in medieval European and Islamic manuscripts is limited to the two dozen or so letters of their alphabets (plus punctuation marks), whereas the nonalphabetical Chinese writing system works with thousands and thousands of characters—from approximately three thousand in shell and bone inscriptions (ca. sixteenth–eleventh centuries B.C.) to 47,035 in the Kangxi Dictionary of 1716. And although other writing systems have developed variant scripts, the differences between the scripts are more considerable in Chinese than in other languages, and some specimens of the more difficult Chinese scripts are hard even for experts to decipher.

In the Chinese conception, calligraphy is closely related to both painting and writing. All three require the same tools (brush, ink, and paper or silk), and many literati engage in two or all three of these arts. It is not surprising that theories of calligraphy, painting, and literature developed along parallel lines and that treatises on these arts use similar or even identical concepts, terms, and images. Consequently, the two treatises presented in this volume will be of interest not only to students of Chinese calligraphy but also to students of Chinese painting and literature.

The Chinese have produced many theoretical works on calligraphy, starting in the second century A.D. We have chosen for translation and annotation two of the more significant ones: Shu pu 書譜 (Treatise on Calligraphy) by Sun

Qianli, completed in 687, and Xu shu pu 續書譜 (Sequel to the Treatise on Calligraphy) by Jiang Kui, published in 1208. We have selected these two treatises because they deal with calligraphy more thoroughly and perceptively than any other works written before or at their time.

Little is known about Sun Qianli, the author of Shu pu, and the sources disagree on several material facts. There is general agreement that his surname was Sun. According to the inscription on his tomb, composed by the well-known poet Chen Zi'ang (661–702), his personal name was Qianli, and his courtesy name Guoting.[1] The same two names are given in Shu duan.[2] But according to Dou Meng's commentary on Shu shu fu, Qianli was his courtesy name, and Guoting his personal name; and the contemporary scholar Xu Bangda suggests (rather unconvincingly, it seems to us) that Sun Guoting, courtesy name Qianli, and Sun Qianli, courtesy name Guoting, may be two different persons.[3] Chen Zi'ang is likely to be correct, because he was a personal friend of Sun's and because Qianli sounds more like a personal name and Guoting more like a courtesy name.

The dates of Sun's birth and death are unknown. At the end of Shu pu, he gives 687 as the year when the treatise was completed, and he states in the body of the work that he began serious study of calligraphy at fifteen (as the Chinese count age, which would be thirteen or fourteen in Western years) and kept it up for more than two ji 紀. (A ji is a period of twelve years.) That would mean that he was born in or about 648.

Nor is his place of birth known. The Taipei scroll of Shu pu, which has the whole text in his own handwriting, begins with the words "Treatise on Calligraphy, First Scroll, by Sun Guoting of Wu Commandery [吳郡]." In the seventh century, as in modern times, Wu Commandery designated the area around Suzhou, in modern Jiangsu Province. The words do not necessarily mean that Sun Qianli was born in Wu or that he lived there. They may simply mean that the family home was or had been there. Other sources place him in different regions. According to Shu duan, he was from Chenliu, in modern Henan Province, southeast of Kaifeng.[4] And the commentary to Shu shu fu locates him in Fuyang.[5] There are two places with this name, one in

1. Chen Zi'ang ji, p. 124.

2. Shu duan, p. 203.

3. Shu shu fu, p. 256; Xu Bangda.

4. Shu duan, p. 203.

5. Shu shu fu, p. 256.

modern Shandong Province and the other in modern Zhejiang Province, near Hangzhou.

As for the date of his death, we can be certain only that it falls between the completion of his *Shu pu* (687) and the death of Chen Zi'ang (702), who wrote his tomb inscription and a commemorative ode about him. The place of his death is specified in the tomb inscription: "He died in the guest house of Zhiye Village [outside] Luoyang."[6] Luoyang is in modern Henan Province.

The sources disagree about the official post or posts that he held. According to Chen's tomb inscription and *Shu duan*, he held the office of Administrative Supervisor of the Guard of the Heir Apparent (*shuaifu lushi canjun*).[7] But the commentary to *Shu shu fu* names him Administrator of the Helmets Section of the Right Palace Guard (*youwei zhoucao canjun*).[8] There are three ways to resolve the discrepancy: one statement may be right and the other one wrong; both may be right, if he held the two positions consecutively; or both may be wrong. At any rate, Sun had not achieved a high position when he died.

Chen Zi'ang's inscription on Sun's tomb and his sacrificial ode both indicate that Sun died rather young.[9] It is therefore hardly possible, for reasons of chronology, to give credence to a statement in *Xuanhe shu pu* which asserts that Emperor Taizong (599–649, reigned 627–649) admired Sun's small-character calligraphy.[10] Chen's tomb inscription and sacrificial ode also hint that Sun had difficulties at the imperial court and became the victim of slander.[11] But what his difficulties were we are not told.

Zhang Huaiguan (eighth century), in a brief biography of Sun Qianli in *Shu duan*, does not mention *Shu pu* but states that Sun wrote a work entitled *Yun bi lun* (Discourse on Wielding the Brush).[12] This must be either an alternative title for *Shu pu* or another work on calligraphy that has not survived. Zhang Huaiguan also judges Sun Qianli as a calligrapher, giving him the grade *neng* 能 ("able") for his writings in the *li*, *xing*, and *cao* scripts, with the further qualification that his *zhen* and his *xing* are not as good as his *cao*.[13]

6. *Chen Zi'ang ji*, p. 125.

7. *Chen Zi'ang ji*, p. 124; *Shu duan*, p. 203.

8. *Shu shu fu*, p. 256.

9. *Chen Zi'ang ji*, pp. 124–125, 151–152.

10. *Xuanhe shu pu*, 18.140.

11. *Chen Zi'ang ji*, pp. 124, 151

12. *Shu duan*, p. 203.

13. Ibid.

Aside from Shu pu and Yun bi lun, no other works, prose or poetry, are credited to Sun Qianli. But two extant pieces of calligraphy in addition to Shu pu are said to be written in Sun Qianli's hand. Their authenticity is doubtful, however. One is Jingfu dian fu (Fu [Poem] on the Jingfu Palace) by He Yan (died 249).[14] The other is Cao shu Qian zi wen (Thousand-Character Text in cao shu).[15] Qian zi wen was created in the sixth century in order to have one thousand characters, with no repetitions, for practicing calligraphy and for other purposes, such as "numbering" the items in a large set of books.

Another insoluble question is whether the Shu pu text as we have it today is Sun's complete treatise on calligraphy or merely the introduction to a longer work that did not survive. Be that as it may, Shu pu is the only text we have, and we must be content with it.

Unlike Sun Qianli, our second author, Jiang Kui, is a man about whose life and works there is much information. His exact dates are not known, however; he was born around 1155 and died around 1221. His place of birth was Poyang, in modern Jiangxi Province. When he was nine or so years old, his father, Jiang E, moved the family to Hanyang, in modern Hubei Province, where Jiang E had been appointed district magistrate. A few years later Jiang E died, but Jiang Kui stayed in Hanyang until 1186, when his uncle Xiao Dezao, a prominent scholar-official and poet, took him to Huzhou (modern Wuxing, in Zhejiang Province). Jiang Kui spent the rest of his life in this area, the lower Yangzi region, which was then the most affluent part of China and had a cluster of lively cultural centers. He lived in Huzhou, Suzhou, Hangzhou (the Southern Song capital), and Nanjing and in their suburbs.

Jiang Kui never succeeded in obtaining a government post. He supported himself by selling his calligraphy and also received substantial financial aid from wealthy friends and patrons. In 1190 a friend gave him the sobriquet Baishi daoren, White Stone Daoist. The appellation alludes to a legendary Daoist immortal who reputedly retired to a place called White Stone Mountain and lived on a diet of boiled white stones. Jiang Kui affected the life of a Daoist recluse while continuing to be active and creative as a poet, musician, composer, calligrapher, and theorist of poetry, music, and calligraphy. He died in Hangzhou.

His extant written works include poems (both shi and ci) and a few prose pieces. Particularly noteworthy among his poems is a series of seventeen ci

14. Jingfu dian fu by He Yan, calligraphy attributed to Sun Qianli, in Sun Guoting Jingfu dian fu.

15. Cao shu Qian zi wen, calligraphy attributed to Sun Qianli.

lyrics with accompanying music, which he composed. The *ci* not only constitute a remarkably fine series but are also a valuable source for the study of Song-dynasty music and musical notation. Jiang Kui's prose writings contain the work with which we are concerned here, *Xu shu pu* (Sequel to the *Treatise on Calligraphy*), as well as an important work on poetics entitled *Shi shuo* (Discourse on Poetry).[16] As the title of *Xu shu pu* implies, Jiang Kui's intention was to write a work in the same spirit as Sun Qianli's treatise. Though critical and even contemptuous of nearly all other earlier writers on calligraphy, he had great respect for Sun Qianli and quotes him extensively. But the word *sequel* should not be understood to denote "continuation." Jiang Kui undertook to deal with the same subject in harmony with what Sun had written, and he took up many aspects of calligraphy that were not touched on in the earlier work.

We find many differences between the two treatises. Jiang's is better organized, more specific, and more concrete than Sun's. He prefers a sober, matter-of-fact, practical approach, whereas Sun often yields to the temptation of casting his statements in an elegant, florid literary style at the expense of clarity. In defense of Sun's *Treatise*, let us point out that he is clearly devoted to his subject and speaks with absolute sincerity and much authority, being a life-long student and practitioner of calligraphy. But he has a tendency to repeat himself, and he often jumps around from one topic to another. To appreciate Sun's manner of presenting his subject matter, we must bear in mind that he writes in an ornate, euphuistic style known as *pian wen* (parallel prose), wherein nearly all phrases are arranged in matching pairs. Of Jiang Kui's *Xu shu pu*, Lin Shuen-fu aptly says that it "excels previous calligraphy texts in at least three interconnected aspects: its systematic and comprehensive theoretical framework, its conception of the written word as an objective entity, and its remarkably rigorous techniques of structural analysis."[17]

Both Sun Qianli and Jiang Kui are highly reputed calligraphers. Sun's writing in *cao* style is exemplified by what most authorities believe to be his autograph of *Shu pu*, reproduced here. Of Jiang Kui's calligraphy no unquestionably genuine examples are extant. But rubbings of two pieces that were probably in his own hand are available. One is a postface to Wang Xizhi's *Preface to the Orchid Pavilion Collection*. It is contained in Wen Zhengming's 文徵明 (1470–1559) collection of rubbings, called Tingyun guan 停雲館, in juan 卷 7. We have used it as the frontispiece of this book. The other is a piece called *Baomu zhuan zhi* 保母

16. Our account of Jiang Kui's life and works is based on Lin Shuen-fu's three studies.

17. Lin, "Chiang K'uei's Treatises," p. 305.

磚志, which Liu Jin'an showed to us at the Palace Museum in Beijing on November 18, 1993.

It remains for us to explain some technical aspects of our translation. We have endeavored to combine faithfulness to the Chinese texts with intelligibility and clarity in English. Whenever a literal version would have misled the English reader, we have preferred a freer rendition. Particularly in the case of Sun Qianli's *Shu pu*, we have found it necessary to forgo much of his literary elegance in order to achieve a clear English version.

A special problem is presented by the names of people. The same person may appear in the Chinese text under two or more different names. The authors chose different names to show respect, to indicate the person's connection with an office or a place, or to provide elegant variation. For example, the calligrapher Zhang Zhi appears in our two texts with the names (1) Zhang Zhi, (2) Boying (his courtesy name), and (3) Zhang Boying (his surname plus courtesy name), and (4) with his surname coupled with that of his younger contemporary Zhong You in the combination Zhong Zhang. The most famous calligrapher in Chinese history, Wang Xizhi, appears as (1) Xizhi, (2) Yishao (his courtesy name), and (3) Youjun (General of the Right Army, one of the offices he held) and with his name coupled with (4) that of his son Wang Xianzhi in the combination Er Wang (the two Wangs) and (5) that of Zhong You in the combination Zhong Wang. To avoid confusing the reader, we consistently refer to each person by surname and personal name—here, Zhang Zhi and Wang Xizhi. At the back of the book we list all the people mentioned in the Introduction, treatises, and notes, giving their various names and other pertinent information.

Another problem is presented by the many technical calligraphic terms. Rather than attempting to translate them, we leave them in their romanized Chinese form and explain each in an appended glossary.

The romanization system that we use for Chinese words and names is *Hanyu pinyin*, the official system of the People's Republic of China, which is now taught in most Chinese-language courses in colleges and universities around the world. Those who are more familiar with the Wade-Giles system will find conversion tables from *pinyin* to Wade-Giles in many books—for instance, at the end of Charles Hucker's *Dictionary of Official Titles in Imperial China*.

Through a fortunate accident, the text of Sun's *Shu pu* has been preserved in a scroll that most experts believe to be in the author's own handwriting. We give a reproduction of this scroll, with the permission of its owner, the

National Palace Museum in Taipei. Because it is written in *cao shu* and therefore difficult to read, we also provide a transcription of the same text in regular script, done by Chang Ch'ung-ho, with added punctuation. Of Jiang Kui's *Xu shu pu* there is no autograph. We give a punctuated text written by Chang Ch'ung-ho based largely on the best available edition, which is contained in *Lidai shufa lunwen xuan*. After the text we list the variant readings found in five editions.

Sun Qianli says that he has divided his treatise into six sections. But those who believe the extant text to be the whole treatise have no sure way of determining where each section ends and a new one begins. Proposals for marking the divisions do not agree. If, on the other hand, one believes the extant text to be the preface to a lost treatise, then the problem of division disappears. No such problem exists with regard to Jiang Kui's *Xu shu pu*. It is divided into eighteen sections, with a title at the head of each section. For the sake of convenience, we have numbered the sections.

One English and one German translation of Sun's *Shu pu* already exist. Sun Ta-yü's English translation, published sixty years ago, was a pioneering effort. It reads well but is admittedly very free and skips some difficult phrases. Goepper's German translation, published twenty years ago as part of his *Habilitationsschrift*, is a thorough and scholarly piece of work. Goepper gives not only a careful translation of the text, with profuse annotation, but also an analysis of the ideas contained therein and of Sun's calligraphy as exemplified in the Taipei scroll. We owe much to Goepper, although we do not always agree with him. No translation of Jiang's *Xu shu pu* has ever been published, as far as we know.

It is our hope that this book will help those who read it and who look at the calligraphy to understand some of the complexities of the Chinese art and to appreciate its timeless beauty.

Treatise on Calligraphy (Shu pu)

Sun Qianli

The best calligraphers from antiquity to the present include Zhong You and Zhang Zhi of the Han and Wei dynasties—they are unexcelled; and Wang Xizhi and Wang Xianzhi of the late Jin—they are praised as marvels. Wang Xizhi says: "I have recently surveyed the famous calligraphers. Zhong You and Zhang Zhi are surely unexcelled; the rest are not worth looking at." It is fair to say that after the demise of Zhong You and Zhang Zhi, Wang Xizhi and Wang Xianzhi became their successors. Wang Xizhi further says: "If you compare my calligraphy with Zhong You's and Zhang Zhi's, Zhong You's is even with mine, or, as some people say, mine surpasses his. Zhang Zhi's *cao* is still a little ahead of mine, but he refined his art through long practice, blackening a whole pond with ink.[1] Had I applied myself like that, there is a chance that I would not be inferior to him." This means that he yielded to Zhang Zhi but put himself ahead of Zhong You.

Examining these [four] men's mastery of different styles, we find that although they did not attain the past standards of perfection, they achieved an integrated mastery of every style; therefore, they were not embarrassed when faced with the practical tasks of their art. Critics say: "These four masters stand out as unsurpassed in ancient and modern times, but the modern ones [Wang Xizhi and Wang Xianzhi] are not up to the level of the ancient ones [Zhong You and Zhang Zhi]: the ancient ones have substance, whereas the modern ones have elegance. Substance develops from generation to generation, but elegance shifts with popular fashion. Although in the beginning, writing was fit just to record language, [later] it was modified to become lighter, and with galloping speed the proportions of substance and elegance changed in three stages in continuous development: this is a constant principle of all matter.

1. "When [Zhang Zhi] practiced calligraphy next to a pond, the whole pond turned black" (Si ti shu shi, p. 16).

Estimable is the ability to write in ancient style without being in discord with one's own time and to create modern art without going along with its shortcomings. This is what is meant by the text "Only when elegance and substance are balanced can human perfection be attained."[2] Why should one change back from carved palaces to cave dwellings? Why go back from jade-ornamented carriages to ox carts with spokeless wheels?

Critics further say: "Wang Xianzhi is inferior to Wang Xizhi in the same way as Wang Xizhi is inferior to Zhong You and Zhang Zhi." They believe they grasp the essentials in their critique, but they do not understand the historical development. The li shu of Zhong You is especially distinguished. The cao script of Zhang Zhi is particularly outstanding. These are their two points of excellence—and Wang Xizhi combines them both. When you compare the cao [of Wang Xizhi and Zhang Zhi], you find that Wang adds to this style an element of zhen. When you compare their zhen, you find that Wang gives this style the additional benefit of cao. Although he is a bit inferior when writing in a single script, he has many advantages in his breadth of skill. In sum, each has his shortcomings.

Xie An excelled in writing epistles and had a low opinion of Wang Xianzhi's calligraphy. Wang Xianzhi once wrote [what he thought was] a beautiful letter and sent it to him, expecting him to keep it. But Xie An immediately wrote a reply on the back and sent it back. Wang Xianzhi very much resented this.

Xie An once asked Wang Xianzhi: "How does your calligraphy measure up against your father's [Wang Xizhi's]?" Wang Xianzhi replied: "Mine is definitely better." Xie An then said: "All the critics hold that this is not so." Wang Xianzhi responded: "How much do people nowadays understand, anyway?" Although with this answer Wang Xianzhi temporarily blunted Xie An's condemnation, he surely went too far [by claiming to surpass his father]. True, establishing oneself and enhancing one's reputation serve to reflect honor on one's parents; Zeng Shen refused to enter the street named Better Than Mother. As to whether Wang Xianzhi's brush and ink carried on Wang Xizhi's art—I am afraid that he did not really master the fundamentals, although he continued using [his father's] method in a rough way. Wang Xianzhi went still further when, ashamed to acknowledge that he had acquired the secret of his art through family tradition, he falsely claimed to have received it

2. A quotation from Lun yu, section 6, "Yong ye" 雍也.

from immortals. Isn't such a concept of learning worse than turning one's face to the wall?[3]

Later, Wang Xizhi once went to the capital, and as he was about to leave he wrote an inscription on a wall. Wang Xianzhi secretly erased it, then rewrote it in the same place and thought to himself that he had not done badly. When Wang Xizhi came back and saw it, he sighed and said: "When I left I surely must have been very drunk." Wang Xianzhi felt ashamed. Thus we know that when Wang Xizhi is compared with Zhong You and Zhang Zhi, the difference between them is between breadth and specialization; Wang Xianshi's inferiority to Wang Xizhi is beyond doubt.

When I was fifteen years old, I centered my mind on brush and ink, savored the extant splendors of Zhong You and Zhang Zhi, and absorbed the past principles of Wang Xizhi and Wang Xianzhi. I concentrated to the utmost on the essentials of the art for more than twenty-four years. I failed to reach the stage of "penetrating the wood,"[4] but kept constant my determination to practice "by the pond."[5]

Consider the difference between the xuan zhen ["suspended needle"] and chui lu ["hanging dewdrop"] scripts,[6] [and then consider] the marvels of rolling thunder and toppling rocks, the postures of wild geese in flight and beasts in fright, the attitudes of phoenixes dancing and snakes startled, the power of sheer cliffs and crumbling peaks, the shapes of facing danger and holding on to rotten wood, which are sometimes heavy like threatening clouds and sometimes light like cicada wings; [consider] that when the brush moves, water flows from a spring, and when the brush stops, a mountain stands firm; [consider] what is very, very light, as if the new moon were rising at the sky's edge, and what is very, very clear, like the multitude of stars arrayed in the Milky Way—these are the same as the subtle mysteries of nature: they cannot be forced. Truly, [fine calligraphy] may be called the result of wisdom and

3. An allusion to a passage in Shu jing, section "Zhou guan" 周官: "He who does not study [is like a man who] turns his face to the wall [so that he cannot see anything]."

4. According to an often-repeated anecdote, Wang Xizhi once inscribed a prayer on a wooden tablet. Afterward it was found that the strength of his brush was such that it had penetrated the wood to a depth of three inches. We have not found an early source of this anecdote.

5. See n. 1 above.

6. The terms xuan zhen shu ("suspended needle" script) and chui lu shu ("hanging dewdrop" script) are placed at the head of a list of several dozen different script types in the essay Lun shu by Yu Yuanwen; see Quan Liang wen, 67.12a.

skill achieving joint excellence, of mind and hand acting in harmony. The brush never moves without purpose; when it comes down, there must be direction. Within a single stroke, changes result from alternately raising and lowering the tip; inside a single dot [dian], movement rebounds at the very end of the brush.

How much more is this true when you combine dots and lines to form characters! If you never have model epistles at your side; if you do not bend down over your work, utilizing every advancing inch of the sundial; if you take Ban Chao's refusal [to write] as a precept;[7] if you are satisfied with Xiang Ji's example;[8] if your style consists of letting the brush run wild; if you make shapes by amassing splotches of ink; if your mind is confused about methods of copying; if your hand strays from the principles of controlled movement— in all these cases, it would be wrong indeed to expect beauty and perfection. However, when a gentleman establishes himself he is obliged to cultivate the fundamentals. Yang Xiong called the poetic genres shi and fu petty pursuits in which a grown man does not engage.[9] How much more would this seem to apply, then, to soaking one's thoughts at the minute tip of the brush and immersing one's spirit in pen and ink! Even concealing one's spirit while playing chess is called becoming a hermit;[10] even pleasing one's heart by angling[11]

7. In the biography of Ban Chao we read: "Ban Chao . . . came from a poor family. He took employment as a copyist in a government office in order to make a living, and worked long and hard. He stopped working once, laid down his brush, and said with a sigh: 'A real man, when he has no other ambition, should follow the examples of Fu Jiezi and Zhang Qian and establish merit in a foreign country in order to be enfeoffed as a marquis. How can he long remain laboring with brush and inkslab?'" (Hou Han shu, 47.1571).

8. In the biography of Xiang Ji we read: "When Xiang Ji was young, he studied writing without success; then he studied swordsmanship, also without success. Xiang Liang [his paternal uncle] was angry with him. Ji said: 'Writing is useful only for recording surnames and given names. The art of fencing, if used to fight against one man, is not worth learning. [I want to] learn how to fight ten thousand men.' Thereupon Xiang Liang taught Ji military strategy. Ji was very happy; he came to know the general outline of military strategy and was unwilling to complete his [other] studies" (Shi ji, 7.295–296).

9. "Somebody asked: 'When you, my master, were young, did you not enjoy writing fu?' He said: 'Yes, as a young lad, I carved insects and cut seals.' Then he added: 'A grown man does not do that'" (Fa yan, 2.1a [section 2, "Wu zi" 吾子]).

10. "Wang Tanzhi considered the game of encirclement chess [weiqi] a kind of sedentary retirement" (Shi shuo xin yu, section 21, "Qiao yi" 巧藝; translation adapted from Shih-shuo Hsin-yü, trans. Mather, p. 376).

11. An allusion to the opening of "Diao fu" (Fu on Angling): "Lifting up my purpose to the floating clouds, / Giving pleasure to my body in a thatched hut, / I seek out the far reaches of the Wei River bank / And roam as an angler to please myself."

means that one understands the joy that comes from knowing when to be active and when to retire.[12]

How can these activities be considered on a par with writing, which records rites and music, is as beautiful as immortals, and has infinite variety, like sculpted clay figures, and practical use, like smelting metal? Gentlemen who love the unusual and esteem what is rare appreciate in this art of calligraphy a great variety of shapes and styles; people who investigate minute subtleties and probe abstruse mysteries find in it profound secrets of change. Writers borrow the dregs of its wine; connoisseurs distill its essence. It is indeed an integration of reason; it is a sure bond linking all kinds of talented and intelligent men who excel in it. Certainly it is not for nothing that its essence has been preserved and its appreciation kept intact.

The gentlemen of the Eastern Jin dynasty came to resemble each other through mutual influence. Members of such great families as Wang and Xie, Xi and Yu, even when they did not perfect the subtlest qualities of the art, all absorbed its flavor.[13] From that time on, the art declined. Then people allowed themselves to be guided by uncertain traditions and carried on the worst of what had been handed down. The connection between past and present was broken, and there was no way of finding out about the art. If some understood, they were secretive about it. Consequently, students of the art were confused, and none of them knew the essential principles. They could see only the beauty of a finished piece; they did not understand how it got that way.

Some pay attention to the structure of the characters for many years but are still far from the strict discipline of the art. When they plan to write *zhen*, they do not comprehend it; when they practice *cao*, they go astray. If someone has a shallow knowledge of *cao* or a rough understanding of *li*, that person becomes immersed in this predilection and stubbornly clings to one-sidedness, becoming shut off from access to other avenues. Do they not know that mind and hand meet like different water courses deriving from the same source and

12. An allusion to a passage in *Lun yu*, section 7, "Shu er" 述而: "The Master said to Yan Hui: 'Only you and I have the ability to be active when employed and to retire when dismissed.'"

13. Calligraphers in the Wang family are Wang Dao, his son Shao; Shao's elder brothers Tian and Qia; Qia's son Min; Wang Xizhi; his son Xianzhi; and Dao's grandson Xin, son of Hui. Calligraphers in the Xie family are Xie Shang; his younger brother Xie An; and Xie Yi. Calligraphers in the Xi family are Xi Jian; his son Yin; Tan, another son of Jian's; Yin's son Chao; and Tan's sons Hui and Jian. Calligraphers in the Yu family are Yu Liang; his two younger brothers Yi and Yi (same romanization, different characters); and Liang's grandson Zhun, son of Xi.

that the application of technical skill resembles different branches growing from one tree? When speed is essential for the occasion, *xing shu* is called for. For inscribing or carving on a large square surface, *zhen* is preferred. If *cao* does not contain an ingredient of *zhen*, it is too specialized and meticulous. If *zhen* does not contain some *cao*, it is not in epistolary style. *Zhen* takes dots and lines as its corporeal structure, and curving movement as its living spirit; *cao* takes dots and lines as its living spirit, and curving movement as its corporeal structure. When *cao* violates the principle of curving movement, it cannot form characters; when *zhen* is deficient in dots and lines, it can still record texts. Even though the relations are reversed, the two scripts are generally interconnected. Thus they are also related to the greater and lesser *zhuan* and involved with *ba fen*; they include the *pian zhang* [literary composition] and merge with the *fei bai* technique. But if there is the slightest error in differentiation, the two scripts will be as far apart as Hu and Yue.[14]

As for Zhong You being marvelous with *li* and Zhang Zhi being a sage with *cao*, this is distinguished specialization in a single script to the point of excellence. Although Zhang Zhi did not do *zhen*, dots and lines can be seen everywhere in his calligraphy; although Zhong You did not write *cao*, curving movements abound in his pieces of writing. From their time on, those who did not combine excellence in both scripts were lacking something, rather than being distinguished in the script in which they specialized.

Although *zhuan*, *li*, *cao*, and *zhang* differ greatly in their various uses, each has its beauty; each has its advantage. *Zhuan* should be graceful and connected; *li* ought to be concentrated and tight; *cao* must flow freely; *zhang* has to be restrained and simple.

In later times, writers dignified their calligraphy with elegant spirit and softened it with delicate moisture, animated it with dry strength and blended it with relaxed refinement. Thus it could express their dispositions, giving shape to their sadness and happiness. When we investigate the various stages of dryness and moisture, we find that they have been the same for a thousand years; when we understand the different periods of youth and old age, we find that a hundred years go by in an instant. Alas, one who does not enter the gate of this art will not glimpse its mysteries!

Furthermore, because one writes at a given time, circumstances will provide either discord or harmony. When there is harmony, the writing flows

14. Hu and Yue were "barbarians" in the extreme north and the extreme south, respectively.

forth charmingly; when there is discord, it fades and scatters. To put it simply, there are five reasons for this. Being happy in spirit and free from other duties is the first harmony. Having a feeling favorable to quick apprehension is the second harmony. Genial weather with the right amount of moisture in the air is the third harmony. A perfect match between paper and ink is the fourth harmony. A sudden, unsolicited desire to write is the fifth harmony. But a restless mind and a sluggish body constitute the first discord. An opposed will and constricted energy constitute the second discord. Dry wind and a hot sun constitute the third discord. A poor match between paper and ink constitutes the fourth discord. Exhausted emotions and a tired hand constitute the fifth discord. The distinction between discord and harmony is the difference between good and bad calligraphy. To catch the right moment is less important than to have the right tools; to have the right tools is less important than to have the right mental disposition. When the five discords coincide, the mind is blocked and the hand is checked. When the five harmonies concur, the spirit issues forth freely, and the brush moves with ease. When it moves with ease, there is nothing that it cannot achieve; when the hand is checked, it cannot go anywhere.

It may happen that a master of calligraphy grasps the idea but cannot express it in words; that master will seldom succeed in setting forth the essentials. Someone who hopes to learn the art may aspire to elegance in describing the beauty; but even though that person gives an account of it, the words are still crude. Such people merely present the technical side of the art without bringing out its substance. Without considering my own dark ignorance, I will forthwith present what has become clear to me, hoping to enlarge on the styles and models of the past and guide the capabilities of the future, to eliminate frills and do away with superfluities, to look at surviving examples and comprehend the heart of the matter.

For some time there has existed a work called *Tactics of the Brush*, with a total of seven lines.[15] It contains three pictures of hands, illustrating different positions of holding the brush. The drawings are distorted, the dots and lines unclear and wrong. It circulates all over the country, south and north, and is attributed to Wang Xizhi. Although its authenticity has not been established, it can be used as an elementary tool for instructing the young. Because it is widely current, I do not include it here. Critical writings on calligraphy by various authors are mostly frivolous and insubstantial; without exception,

15. On this work, see Barnhart.

they are concerned merely with the outer form and go astray in regard to the inner principle. I make no use of them in this treatise.

Shi Yiguan's high reputation is based only on historical records; Handan Chun's good example has been given empty praise in embroidered writings. From Cui Yuan and Du Du on, from Xiao Ziyun and Yang Xin to the present, successive generations of calligraphers stretch far and long; those practicing the art have been numerous. Some of them have had great fame that has never been extinguished; even after their lives end, their work still shines brightly. Others have used their connections to raise the value of their works; but when their bodies perish, the worth of their calligraphy declines. In addition, some calligraphic writings have rotted or have been destroyed by worms and hence have not been preserved, or they have been stashed away by collectors and are thus out of sight. Rare are the occasions when one happens upon such works and can examine and appreciate them. Qualitative judgments become confused and are difficult to make. Those who are famous now and whose calligraphy is extant do not need to be damned or praised; their ranking order is automatically established.

The six classes of characters go back to Xuan Yuan;[16] the eight styles of calligraphy arose under the First Emperor of Qin.[17] The history of this art is long, its application wide. But its present and past are different, its beauty and substance separate. Because I am unfamiliar with these matters, I will pass over them. Then there are calligraphic styles, such as "dragons" and "snakes," "clouds" and "dew," "tortoises" and "cranes," "flowers" and "blossoms," that arise when a writer roughly depicts a real object or records a lucky omen that has just been sighted.[18] Technically, such forms belong to painting, not

16. The six classes of characters, as set forth by Xu Shen in his *Shuo wen jie zi*, are (1) *zhishi* 指事, "self-explanatory characters"; (2) *xiangxing* 象形, "pictographs"; (3) *xingsheng* 形聲, "pictophonetics"; (4) *huiyi* 會意, "associative compounds"; (5) *zhuanzhu* 轉注, "mutually explanatory characters"; and (6) *jiajie* 假借, "phonetic loans." (See *Shuo wen jie zi*, 15A.16.)

17. The eight styles of calligraphy, as defined by Xu Shen in his *Shuo wen jie zi*, are: (1) *da zhuan* 大篆, "greater seal script"; (2) *xiao zhuan* 小篆, "lesser seal script"; (3) *ke fu* 刻符, "script for courier vouchers"; (4) *chong shu* 蟲書, "wiggly-worm script"; (5) *mo yin* 摹印, "script used in seals"; (6) *shu shu* 署書, "script for ornamental tablets"; (7) *shu shu* 殳書, "script for inscriptions on weapons"; and (8) *li shu* 隸書, "clerical script." (See *Shuo wen jie zi*, 15A.2b.)

18. Some such fanciful scripts are listed in *Mo sou* (Tang dynasty), including *long shu* 龍書, "dragon script"; *yun shu* 雲書, "cloud script"; *gui shu* 龜書, "tortoise script"; *niao shu* 鳥書, "bird script"; *he tou shu* 鶴頭書, "crane's-head script"; *chui lu zhuan* 垂露篆, "hanging dewdrop seal script"; *she shu* 蛇書, "snake script"; and *hua shu* 花書, "flower script."

calligraphy. Being irrelevant to our art, these are not matters that I shall discuss in detail.

For generations there has been handed down a *Treatise on Brush Technique* in ten chapters, supposedly by Wang Xizhi, addressed to his son Wang Xianzhi.[19] The diction is vulgar and the reasoning flimsy, the meaning perverse and the wording stupid. A careful examination of its content and style shows it definitely not to be by Wang Xizhi. Wang Xizhi's position in life was important and his talent lofty; his personality was pure and his verbal style refined. His fame has not been extinguished, and his calligraphy is still extant. To compose every piece of writing, to explain every subject, he always made a thorough study [first], drawing on ancient sources even when he was in a hurry. When a father gives instructions to his precious son and heir in order that his conduct be harmonious and his morality correct, how could style and content possibly be as decadent as they are in this treatise? The author further says in the treatise that Zhang Zhi was his fellow student. This shows even more clearly that the work is baseless and false. If the reference is to the Zhang Zhi who lived at the end of the Han dynasty, this is chronologically impossible. There should then be a man of the Jin dynasty with the same name. But if so, why are the historical records silent about him? The work has neither the quality of exhortation nor the authority of a classic. We must reject it.

What one understands in one's mind is not easy to express in words; what one can say in words is still difficult to put on paper with ink. I can only roughly outline the shape of my topic and state its basic principles in general terms. I aspire to consider what I have seen and heard only vaguely and to gather together the most exquisite aspects of the art. Where I have failed and missed, let us wait for future writers to make up the want.

I shall now set down the calligraphic principles of holding, moving, turning, and employing the brush in order to drive out misunderstandings. Holding involves such matters as depth and shallowness, length and shortness. Moving involves such matters as verticality and horizontality, connecting and checking. Turning involves such matters as hooks and circles, twists and turns. Employing involves such matters as dots and lines, face to face and back to back. Furthermore, I shall bring together the various techniques and unite them into a single approach; I shall array the different specialties and weave together their multiple excellencies. I shall point out what the masters of the past have not achieved, and set up patterns for the students of the future. I

19. See Barnhart, p. 7.

shall trace the art to its roots and sources and study its diversification into branches and streams. The important thing is to make the wording simple and the reasoning sound, the writing clear and the content comprehensive, so that when someone unrolls my scroll, it will be understood, and when someone puts brush to paper, there will be no obstacles. I shall not bother with erroneous statements and false theories. What I am setting forth now will surely benefit students.

Wang Xizhi's calligraphy has been extensively praised and studied by every generation; it can well serve as a model to help students find their own way, for it not only integrates the best of past and present but also shows deep feeling and harmony. Therefore the number who copy it and make rubbings of it increases daily, and the sum of those who study and practice it grows from year to year. Whereas most of the works of other famous calligraphers before and after Wang have been dispersed and diminished, his works alone have stood the test of time. Does this not show their power?

I shall try to briefly explain the reasons for this as I see them. *The Eulogy of Yue Yi*,[20] *The Yellow Court Classic*,[21] *The Poem Praising Dongfang Shuo's Portrait*,[22] *The Exhortations of the Imperial Tutor*,[23] *The Preface to the Orchid Pavilion Collection*,[24] and *The Formal Notification*[25] have all been popular through the ages and are thus preserved; they are perfect examples of *zhen* and *xing*. When Wang Xizhi wrote *The Eulogy of Yue Yi*, his feelings were mostly melancholy; when he wrote *The Poem Praising Dongfang Shuo's Portrait*, his mind was dwelling on unusual matters; in *The Yellow Court Classic*, he reveled in vacuity; in *The Exhortations of the Imperial Tutor*, he twisted and turned in response to conflicting views; in writing about the happy gathering at the Orchid Pavilion, his thoughts roamed and his spirit

20. *The Eulogy of Yue Yi* by Xiahou Xuan was written in *zhen shu* by Wang Xizhi in 348.

21. *The Yellow Court Classic*, attributed to Lao Zi, deals with the prolongation of life.

22. *The Poem Praising Dongfang Shuo's Portrait* was composed by Xiahou Zhan 夏侯湛 (243–291) and written out by Wang Xizhi for his friend Wang Xiu 王脩 in 356, as he states in his postface.

23. *The Exhortations of the Imperial Tutor* is not extant today in any form.

24. *The Preface to the Orchid Pavilion Collection* is Wang Xizhi's most famous work. It dates from the year 353. The text is included in his biography, *Jin shu*, 80.2099. Translations appear in Grube, pp. 253–254; Wilhelm, p. 127; Margouliès, pp. 397–398; and Bischoff. For a devastating review of Bischoff's translation, see Holzman.

25. *The Formal Notification* was composed by Wang Xizhi in 355 to inform his ancestors of his resignation from his post as Governor of Kuaiji. The text is in his biography, *Jin shu*, 80.2101.

soared; in The Formal Notification, his feelings were predominantly sad. This is what is meant by the statement "When dealing with pleasure one laughs; when writing of sorrow one sighs."[26] Wang need not (like Bo Ya) rest his thoughts to create the slow rhythm of flowing waves; he need not let his spirit glide over the Sui and Huan Rivers to think up colorful writing. Although he could clarify a matter at first glance, still his mind sometimes went astray and he made mistakes.

Everybody assigns different names to the different styles [of writing], and people force labels on different schools. They do not know that as emotions stir, so words are shaped—that is how one can understand the Shi jing [The Classic of Songs] and the Chu ci [The Songs of Chu]. They do not know that the associations of brightness with joy and of darkness with sorrow are rooted in the basic nature of Heaven and Earth. If you miss these emotional and cosmic connections, your reasoning is at variance with the real substance. Considering the origins of calligraphy, how can there then be a good style?

Although the movements of the brush are yours to determine, what you need at the moment are the established norms. A miss by a hair's breadth is a failure by a thousand miles, but if you know the art, you can make it fit all demands. The mind must never weary of striving for perfection; the hand must never neglect constant practice. When one has reached complete mastery and the norms are clearly understood, the work will naturally flow freely and easily; mental conception will come first and the brush will follow, casually and without effort; the ink will flow freely and the spirit will soar. Indeed, [mastery] is like Sang Hongyang's mind, which calculates without limit; like Cook Ding's eyes, which need not see the whole ox.

Interested people used to come to me for instruction. I gave them a rough overview and taught them in that way. The mind of each student was alert and the hand complied; words were forgotten as the purpose was achieved. Although they did not completely master the art, they reached their goal.

For understanding basic ideas and principles, the young are inferior to the old; but for mastering technique, the old are inferior to the young. For grasping ideas, the old are outstanding; for practicing technique, the young are better able to exert themselves. When students exert themselves without stopping, they pass through three stages. Each stage changes to the next as its po-

26. This is a nearly literal quotation from Wen fu "When dealing with something happy one must laugh, when speaking of something sad one sighs" (Wen fu, first page of Chinese text). For Chen's somewhat different translation, see ibid., p. xxii.

tential is exhausted. When you first learn to structure your writing, seek only the level and straight. At the first stage you have not arrived yet. At the middle stage you have gone too far. At the stage of comprehensive mastery, the person and the calligraphy will be ripe and mature.

Confucius said: "At fifty I knew Heaven's will; at seventy I followed my heart."[27] Thus, when one understands what is level and what is precipitous, then one comprehends the rationale of change; when one first plans and then moves, the movements do not lose their proper place; and when one speaks only at the right time, the words hit the mark. That is why Wang Xizhi's calligraphy was so marvelous in his late years: because his thoughts were penetrating, because his disposition was tranquil, not extreme or fierce, and because his personality was controlled and far-reaching. From Wang Xianzhi on, calligraphers have strained too hard and used affectations to form a personal style. Not only have their efforts been inadequate but their spiritual content has fallen short.

Some people deprecate their own work; others boast of their calligraphy. Those who boast will reach a limit; they are incapable of being guided toward further progress. Those who deprecate are inhibited but are bound to break through. Alas! There are those who study, yet do not succeed; but there has never been anybody who succeeded without studying. When one examines these facts, they can definitely be understood.

Many different situations exist. Sometimes hard and soft are brought together in one style, or diligence and relaxation unexpectedly lead to separate styles. At times calligraphy is gentle and mild while the inside is strong and solid; at other times it twists and breaks while the outside is angular and showy. When you scrutinize, you must look for minute details; when you imitate, the thing to strive for is close resemblance. Yet imitation is unable to achieve close resemblance, and scrutiny is unable to seize the minute details; the structure of the writing is still loose, the shapes have not been fixed. Such calligraphers have not seen the grace of a dragon leaping from the deep; they only echo the ugly croaking of a toad at the bottom of a well. Whoever speaks ill of Wang Xizhi and Wang Xianzhi and slanders Zhong You and Zhang Zhi cannot deceive the eyes of contemporaries nor stop the mouths of future generations. Students, beware!

Some are eager to be swift without having learned how to linger; others are intent on being slow without having mastered speed. In fact, force com-

27. A quotation from Lun yu, section 2, "Wei zheng" 為政.

bined with speed is the key to superb beauty, and deliberate lingering leads to perfect appreciation and comprehension. If you proceed from lingering to speed, you will reach a world of consummate beauty; but if you get stuck lingering, you will miss the ultimate perfection. Being able to move quickly without haste—that is what may be called true lingering; but lingering for the sake of delay—how can this be considered appreciative understanding? Unless the mind is at ease and the hand skilled, it is difficult to achieve both speed and lingering.

Having assembled all the attractive qualities, it is important to preserve inner strength. When inner strength is preserved, life-giving elements will be added. It is like the branches and trunk of a tree in luxuriant growth: when hit by frost and snow, their strength increases; like blossoms and leaves in lush profusion, they reflect the splendors of clouds and sunlight. If inner strength predominates disproportionately, vigorous beauty will be diminished. This is like a strong branch on a precipitous incline, like a huge rock blocking the road: although beauty is lacking, vigor remains. Sometimes beauty is outstanding but inner strength is deficient. This is comparable to a fragrant grove with fallen blossoms, whose vain splendor has no support, or to an orchid pond with floating duckweed—transient verdure without roots. Thus you may know that one-sided success is easy to achieve, but perfect beauty is hard to come by.

Even when a single master is taken as a model, many different styles will develop. Every person follows a natural inclination to shape one's own basic character: If a person is straight, the writing will be rigid and lacking in vigorous beauty; if a person is hard and ruthless, it will be stubbornly unsubmissive and lacking in suppleness; those who are overly careful will have the defect of being unrelaxed; those who are careless and superficial will be lacking in exactitude; those who are genial and gentle will suffer from softness; those who are impetuous will be excessively hasty; those who hesitate will get stuck; those who are clumsy will limp and lack sharpness; those who are trivial and petty will have the style of vulgar clerks. These are all people who go their own way and give in to their individual defects.

The Yi jing says: "When you contemplate the natural patterns of Heaven, you can examine the vicissitudes of successive periods; when you contemplate the cultural patterns of men, you can transform the whole world."[28]

28. From the Yi jing Commentaries, section 22, "Bi" 賁. For an earlier translation, see I Ching, trans. Baynes, p. 495.

How much more is it true that the marvelous features of calligraphy are related to the individual! If your method is not perfect, you will miss its ultimate secrets, but the flow of inspiration will still spring from the depths of your heart. You must understand the use of dots and lines and make a broad study of the historical development of characters, absorb *chong zhuan*, and combine *cao* and *li*. When all Five Elements are utilized in making things, an infinity of shapes are created; when all the eight instruments are played in compositions, feeling and understanding are unlimited. It is the same [with calligraphy].

When identical strokes recur, their shapes should be different; when various dots are together, their appearances should be unalike. A single dot determines the outline of a whole character; a single character sets the standard for a whole piece. There may be differences, but there should be no conflicts; there ought to be harmony, but not repetition; you may linger, but you should not stand still; you may move swiftly, but you should not rush. Dry strokes bring out the moistness; when the ink is too thick, it leads to dryness. Avoid compasses and rulers when making square and round shapes; uniformity should be concealed by curved and straight lines. Alternate between obvious and recondite shapes, between clearly discernible and hidden patterns. Hold all the different styles ready at the tip of your brush; harmonize all the varying emotions on your paper. Let there be no divergence between your mind and your hand; forget all the rules. Then you can ignore Wang Xizhi and Wang Xianzhi and yet make no mistake; you can depart from Zhong You and Zhang Zhi and yet be successful.

Jiang Shu and Qing Qin, though different in appearance, were equally attractive women. The Marquis of Sui's pearl and Bian He's jade, though of different materials, were equally valuable. Why should one make an exact copy when sculpting a crane or painting a dragon, thereby debasing the originals? Why should one, having caught a fish or captured a rabbit, still think of the trap and the snare?[29]

I have heard that you can discuss feminine beauty only when you have at home a woman as attractive as Nan Wei and that you can speak of sharpness

29. A reference to *Zhuang zi*, near the end of section 26, "Wai wu" 外物: "The fish trap exists because of the fish; once you've caught the fish, you can forget the trap. The rabbit snare exists because of the rabbit; once you've caught the rabbit, you can forget the snare" (trans. Watson, p. 302).

only when you have a sword as good as Longquan.[30] These two sayings exaggerate, yet they concern a pivotal matter.

Formerly I strove hard to do calligraphy and believed that I was doing well. I showed some of my work to those who at that time had reputations as experts. They did not even look at what I had done well, and where there were faults, they nevertheless expressed their admiration. They looked but did not really see, and based their understanding on what they had heard from others. Some, being advanced in age and holding high positions, despised my work. I then wrapped my calligraphy in decorated silk and inscribed it as an old work. Thereupon the so-called experts changed their judgment [for the better], and the foolish followed the general drift. They vied with each other in praising the smallest details and hardly ever criticized the faults of my brushwork. It was like Marquis Hui's love of forgeries and like Zi Gao, Duke of She's fear of the real dragon. Then I understood why Bo Ya had stopped playing the tune of the running stream.

Cai Yong was not wrong in perceiving the acoustic qualities of burning wood; Bo Le did not look blindly at horses. Because their appreciation was deep and subtle, their ears and eyes were not obstructed. Ordinary people could not recognize the musical potential in the sound of a burning piece of wood nor perceive the qualities of an outstanding horse confined in a lowly stable. Cai Yong would no longer be admirable, and Bo Le's excellence would not be appreciated any more.

When Wang Xizhi, upon meeting an old woman, inscribed a fan for her, she resented it at first, then asked him to inscribe more fans. When a disciple procured a table on which Wang had written, the disciple's father scratched off the calligraphy, and the son regretted it.[31] These instances show the difference between understanding and not understanding calligraphy. A man of accomplishments feels frustrated among people who do not understand him, and comfortable only among those who understand him; the lack of understanding is not surprising. Therefore, Zhuang Zi says that the morning mushroom knows nothing of the end of the month and the start of a new one,

30. Longyuan was a famous sword of antiquity. Because the character *yuan* 淵, being the personal name of the founder of the Tang dynasty, was taboo in Tang times, the character *quan* 泉 was substituted for it in Tang texts. This sentence is taken almost verbatim from a letter by Cao Zhi to Yang Xiu; see *Cao Zhi ji jiaozhu*, p. 154.

31. These two anecdotes about Wang Xizhi are told in *Lun shu biao*, pp. 53 and 54.

and that the summer cicada knows nothing of spring and autumn.[32] Lao Zi says: "When an inferior student hears about the Way, he laughs out loud; if he did not laugh, it would not be worthy of being considered the Way."[33] We should not, holding ice in our hands, blame the summer insects for not understanding.[34]

From Han and Wei times on, many have discussed calligraphy in profuse detail in a variety of good and bad treatises. Some rehash ancient writings, and what they say is clearly no different from what has been said before; some develop new theories, which are of no use for the future. They only make complex matters more complex and leave deficiencies deficient. I have written my work in six sections, divided it into two scrolls, arranged it for practical use, and entitled it "Treatise on Calligraphy." Future students may take it as a model, and those within the Four Seas who understand the art may peruse it. I have not included in it any mysterious secrets.

Written in the third year of the Chuigong era (687).

32. A quotaton from *Zhuang zi*, chapter 1, "Xiaoyao you" 逍遙遊.

33. A quotation from *Dao de jing*, section 41, "Tong yi" 同異.

34. An allusion to a passage in *Zhuang zi*, chapter 17, "Qiu shui" 秋水: "You cannot speak about ice with a summer insect, which is limited to a single season."

Sequel to the "Treatise on Calligraphy" (Xu shu pu)

Jiang Kui

[1] General Remarks

The calligraphic scripts zhen, xing, and cao derive from chong zhuan, ba fen, fei bai, and zhang cao. Round, strong, antique, and simple strokes derive from chong zhuan. Dots, lines, bo strokes, and initial strokes derive from ba fen. Turns, changes of direction, face-to-face strokes, and back-to-back strokes derive from fei bai. Simple and pleasant strokes derive from zhang cao. But zhen, cao, and xing each have their own stylistic characteristics. Writers like Ouyang Xun and Yan Zhenqing treat zhen as cao. Writers like Li Jianzhong treat xing as zhen. Also, some among the ancients were particularly good at zheng shu, others were especially good at cao shu, and still others were especially good at xing shu; it is true that one cannot be perfect in all these scripts. Someone has said that a thousand cao shu characters are not worth as much as ten xing shu characters, and that ten xing shu characters are not as good as one zhen shu character.[1] That person believes that cao is the easiest and zhen the most difficult style. Does that person really understand calligraphy? It is likely that when one concentrates on copying ancient models, there will be a lack of individual spirit. When one specializes in vigorous strokes, one cannot avoid a vulgar effect. Giving priority to becoming familiar with all the styles and to making mind and hand work together is perfect. Master White Cloud and Ouyang Xun in their Secrets of Calligraphy also speak about this summarily. Sun Qianli discusses it in great detail. All these may be consulted.

1. We have not found the source of this quotation and do not know who the "someone" is. A similar statement is contained in Shu gu by Zhang Huaiguan: "Taking Wang Xizhi as the standard, 105 characters of his cao shu and zhen are worth as much as one row of xing shu; and three rows of xing shu are worth as much as one row of zhen." (p. 150).

[2] *Zhen shu*

It is commonly believed nowadays that [in writing] *zhen shu* one should strive for evenness and squareness. But this is one of the errors of the calligraphers of the Tang dynasty. There is no better *zhen shu* than Zhong You's; next to him is Wang Xizhi. We can see now that all the calligraphy of these two men is casual and elegant, and with them the brush moves freely in all directions; how can one say they are restricted to evenness and squareness? This is surely because during the Tang dynasty calligraphy was used as a criterion, and the needs of the examination system adversely affected the calligraphy of officials and scholars. Yan Zhenqing's book *Directions for Calligraphy by Aspiring Officials*[2] may be cited as proof. Ouyang Xun, Yu Shinan, Yan Zhenqing, and Liu Gongquan succeeded one another; therefore, the Tang writers executed calligraphy strictly to fit the compass and the square; they did not revive the untrammeled spirit of the Wei and Jin dynasties.

Whether a character is long or short, large or small, tilted or upright, tight or loose—these matters are natural and cannot be made uniform. For example, the character *dong* 東 [east] is long whereas *xi* 西 [west] is short, *kou* 口 [mouth] is small whereas *ti* 體 [body] is large, *peng* 朋 [friend] is tilted whereas *dang* 黨 [clique] is upright, *qian* 千 [thousand] is tight whereas *wan* 萬 [ten thousand] is loose. Characters with many strokes should be lean, but characters with few strokes should be plump. The reason for the excellence of the Wei and Jin calligraphers is that they utilized to the fullest the true form of each character without letting their personal opinions interfere. Some who favor the square and straight eagerly imitate Ouyang Xun and Yan Zhenqing. Others who prefer even and round shapes take Yu Shinan and Zhi Yong as their models. Then there are those who say that the style should be refined and squat; if so, then it will naturally be even and square. This is again the defect of Xu Hao. Some say that writing should be relaxed; if so, then it will naturally not be vulgar. This is again the style of Wang Xianzhi. How can any of these styles exhaust the complete beauty of calligraphy?

In *zhen shu* there are eight types of brushstrokes. I once collected samples of calligraphy by ancient masters and arranged them in a chart. I shall now summarize the important points. Dots are the eyebrows and eyes of a character. They depend entirely on the spirit of eye contact. Some face each other; some are back to back. Their shape varies from character to character. Hori-

2. Not extant today.

zontal and vertical lines are the flesh and bones of a character. They should be strong and straight, even and clean. There are techniques for starting and finishing each stroke. The length must be appropriate. The finish of each stroke must be strong and definite. Pie and fu are the hands and feet of a character. Their expansions and contractions are different in each case, with many variations, like the fins of fish and the wings of birds moving happily and contentedly. Tiao ti are the paces of a character; they should be steady. The tiao ti of the Jin calligraphers either slant downward or point horizontally outward. Yan Zhenqing and Liu Gongquan began to make these strokes with a vertical brush tip, which caused the untrammeted spirit to disappear.

Turns and bends are the methods of the square and the round. In zhen one mostly uses bends; in cao one mostly uses turns. Bends require a short pause, a rest that gives strength. In turns there must not be any hesitation; if one hesitates, there will be a lack of vigor. But in zhen there must be some turns in order to have vigor; in cao there must be some bends in order to have strength. A knowledge of this is indispensable. In a "suspended needle" [xuan zhen] the stroke must be absolutely straight from top to bottom, like a suspended rope. When a hanging stroke turns upward at the end, it is called a "hanging dewdrop" [chui lu]. Therefore, when Zhai Qinian asked Mi Fu, "What should calligraphy be like?" Mi Fu answered, "Whatever hangs down must turn upward; wherever one goes, one must turn back." This can be achieved only by those who are very accomplished and very experienced. In the calligraphy handed down by the ancients, every dot and every line is clearly different because they had perfected the art of using the brush. From Wang Xianzhi on, there have been many defects in brushwork. [Having written] a single character, people [try to improve by] making the long and short strokes complement each other, the slanted and straight lines prop each other up, the plump and lean elements intermingle. By these means they seek to make the character attractive after they have written it. In recent times this practice has become even more prevalent.

[3] Use of the Brush

Brushstrokes should not be too thick; thick strokes look sullied. They should not be too thin, either; thin strokes look withered. No sharp ends should stick out, lest the shape be too haphazard. The essentials of a stroke should not be hidden inside the stroke, lest the appearance lack vigor. Avoid making the top part large and the bottom part small. Avoid making the

left part high and the right part low. Avoid having too much in front and too little in back. Although Ouyang Xun's composition is constricted, his brushwork includes all variations. Even with small-character *kai*, his calligraphy is beautifully relaxed, following the tradition of Zhong You and Wang Xizhi. Those who came after him could not equal him. In composition, Yan Zhenqing and Liu Gongquan differed from the ancients and were one-sided in their brushstrokes. In my critical opinion, these two men mark a change in calligraphy. In the centuries since then, calligraphers have vied in imitating them. The strength and sturdiness of their handwriting and painting are not unhelpful to the development of calligraphy, but the noble style of the Jin and Wei dynasties has been swept away. However, the limpid strength of one side of Liu's large characters is a joy and makes his calligraphy even more wonderful. Recent calligraphers have imitated him, but because they have been unable to rid themselves of vulgar impurity, their work is not worth looking at. This goes to show that excessive thickness is not as good as thin hardness.

[4] *Cao shu*

Cao shu is like a person sitting, reclining, walking, standing, pressing the hands together,[3] yielding, arguing; like taking a boat or galloping a horse, like singing and dancing, jumping around—like all such movements that are carried out deliberately. Furthermore, the form of each character may undergo many changes involving starts and responses. A certain start calls for a certain response, each having its own rationale. Of the characters written by Wang Xizhi, the most frequent ones are Xizhi [his name], *dang* 當 [ought], *de* 得 [get], and *wei* 慰 [soothe]. Each one occurs several dozen times, and they are never written the same way, and yet they are never quite unalike. One may said that Wang Xizhi was able to "follow his heart's desire without overstepping the boundary."[4]

Generally speaking, anybody who wants to learn *cao shu* must first adopt the correct method and imitate the *zhang cao* of Zhang Zhi, Huang Xiang, and Suo Jing. Then the composition will be even and straight, and the movement of the brush will manifest its source. Thereafter one must imitate Wang Xizhi, developing one's own variations and being inspired to add unusual and abrupt features. If one randomly studies many calligraphers, then some characters will

3. A gesture of respect.

4. A quotation from Lun yu, section 2, "Wei zheng" 為政.

be good and others awkward; there will be many mistakes in brushwork. Elements that ought to be linked will be separated, and elements that ought to be separated will be joined. One will not know when elements should face each other and when they should stand back to back; one will not know when to start and when to stop; one will not understand when to turn and change; one will arrange strokes arbitrarily and compose designs without controlling the brush. There will be a lack of understanding, and everything will be topsy-turvy. Calligraphers themselves, on the contrary, will think that they are original and marvelous. This was the situation after Wang Xianzhi; it is even worse now. But people of insufficient training, although they remember many instances of good style, are unable to rid themselves of vulgarity. If they can become natural and unrestrained, their calligraphy will be superior to that of others.

Before the Tang dynasty, *cao* characters were mostly written individually, connecting at most two characters. Connecting several dozen characters without a break is called "linked silk threads." Even though this goes back to the ancients, it is not admirable; on the contrary, it is a severe defect. The ancients wrote *cao* in the same way as the moderns write *zhen*, never carelessly. Their links of characters are subtle connections. I have examined their characters: the places where there are dots and lines are always heavy; the places where there are neither dots nor lines are always connected, and the brush is always light. Although there is much variety, all the rules are always observed without disorder. Zhang Xu and Huai Su are considered the most unconventional in their methods, yet they never violated these rules. In recent times, Huang Tingjian claimed that he had obtained Huai Su's secret method. This was a change in *cao shu*. From then on, *cao shu* has no longer been good.

Tang Taizong said: "Every line is like a bundle of earthworms entwined together; every character is like a heap of autumn snakes."[5] He dislikes this kind of calligraphy because it has no bones. The strokes of a brush may be slow or quick, may be made with a visible or a hidden tip, may be linked to the preceding text or connected with the following character. The brush may sometimes move slowly and at other times fast, it may move on or rest. Slowness goes with imitating the ancients, and speed may produce marvelous results. A visible tip will show up the spirit; a hidden tip will restrain energy. In horizontal, slanting, curved, and straight lines, hooks, circular lines, and spirals, strength is the most important element. But the lines should not be

5. See Tang Taizong's postscript to the biography of Wang Xizhi, *Jin shu*, 80.2108.

confused with each other. Confusing them is vulgar. Horizontal strokes should not be too long. If they are long, then changes of direction come too late. Straight lines shold not be too frequent. If they are frequent, then the style will be spiritless. Instead of na ㇏, na 捺 is used; instead of chuo 辵, fa 發 is used. Na 捺 is also used instead of chuo 辵. Only pie ノ is sometimes used [without substitution]. When the momentum has been completed, a "suspended needle" [xuan zhen] is used. When the momentum has not been completed and another stroke is to be used, it is best to use a "hanging dewdrop" [chui lu].

[5] Use of the Brush[6]

Brushwork is like bent hairpins, like traces of a leaky roof, like lines made by an awl in the sand, like cracks in a wall. These are all statements made by later authors.[7] In "bent hairpins" it is desirable to have sharp turns and curves in order to have strength. In "traces of a leaky roof" it is desirable to be even and not show a tip. In "lines drawn by an awl in the sand" it is desirable to have no beginning and no end. In "cracks in a wall" it is desirable to make [the characters] look as if they were made without a clever scheme. But in all these situations it is not necessary to proceed like that.

When the brush is vertical, the tip is concealed. When the brush leans, the tip appears. The brush sometimes rises, sometimes descends; its tip is sometimes invisible, sometimes visible; and yet its marvelous spirit comes out. When the tip of the brush is in the middle of the stroke, then there will be no defects, no

6. Note that section 3 has the same heading.

7. "Zhang Xu's 'bent hairpin,' Yan Zhenqing's 'leaky roof,' and Wang Xizhi's 'lines drawn by an awl in the sand' and his 'impressions made by a seal in mud' . . . these all employ the same brush technique: the mind does not know what the hand is doing, and the hand does not know what the mind is thinking—that is all there is to it" (Lun shu by Huang Tingjian, p. 356). "Zhang Yanyuan said: 'Formerly, when I studied calligraphy, even though I applied myself diligently, I never achieved the greatest excellence. Then I consulted Chu Suiliang, and he said: "The use of the brush should be like the impression of a seal in mud." I thought about this but did not understand it. Later, on a river island, I happened to see that the sand was level and the ground quiet, which produced in me happiness and the desire to write. On the spur of the moment, I used a sharp point and drew calligraphy in the sand, with strong, bold lines, clear and sharp and beautiful. Only then did I realize that using the brush is like drawing lines in the sand with an awl, concealing the tip, which causes the strokes to be solid'" (Shu Zhang zhangshi bifa shi'er yi, p. 280). "Huai Su said: 'When I look at the summer clouds . . . and also when I come upon cracks in a wall by the road, [I see that] each of them is natural.' Yan Zhenqing said: 'What about traces of a leaky roof?' Huai Su rose, pressed Yan's hands, and said: 'I get it'" (Shi Huai Su yu Yan Zhenqing lun cao shu, p. 283).

matter whether one moves to the left or to the right. Therefore, each dot and each line contains three turns. Each *bo* and each *fu* has three turning points. Each *pie* also has several shapes. A single dot must respond to other strokes. Two dots must respond to each other. When there are three dots, the first must start, the second carry on, and the third respond. When there are four dots, the first must start, the second and third carry on, and the fourth respond.

According to Bi *zhen tu*: "When horizontal and vertical [strokes] resemble each other, they look like the beads of an abacus; this is not calligraphy."[8] When the characater *wei* 囗 [surround] is written in *xing* or *cao*, the corners must be inconspicuous, it is important for it to be spacious and beautifully rounded. "When the mind is correct, the stroke will be correct."[9] "The intent is there before the brush comes down; the written character follows the mind."[10] These are both famous sayings, but they do not hit the mark. For *xing*, diligence is not as good as naïveté, weakness is not as good as strength, slowness is not as good as speed. The most important thing is to wash away vulgar, conventional attitudes; then perfection will come naturally. It is most important to grasp the brush firmly; when the brush moves, it must move in a lively manner. It must not be moved by the fingers but by the wrist. When one holds the brush in one's hand, the hand should not control the movement. The wrist should move it, but the wrist should not be stiff. Also, calligraphers should have some knowledge of seal script; they should know the origin and development of dots and lines—for example, the difference between the characters *zuo* 左 [left] and *you* 右 [right], between *ci* 刺 [stab] and *la* 剌 [cut], betwen *wang* 王 [king] and *yu* 玉 [jade], between *shi* 示 [show] and *yi* 衣 [clothes]. The outlines of *feng* 奉 [receive], *qin* 秦 [Qin], *tai* 泰 [great], and *chun* 春 [spring], are similar, but their exact shapes are different. When their origins are understood, these [differences] will not be superficial.

Sun defines the methods of holding, moving, turning, and employing the brush. *Holding* refers to long and short, shallow and deep. *Moving* refers to vertical and horizontal and the use of muscle. *Turning* refers to hooks and curves, which must wind without a break. *Employing* refers to dots and lines being face to face or back to back. These distinctions are not trivial.

8. This statement is not in the extant text of Bi *zhen tu*.

9. This is Liu Gongquan's answer to Emperor Muzong's (reigned 820–824) question about the best use of the brush; see Liu's biography, *Jiu Tang shu*, 165.4310.

10. This is similar to the following statement in *Ba jue*: "The intent is there before the brush comes down; the wording comes later than the thought" (p. 98).

[6] The Use of Ink

For *kai*, the ink should always be dry, but not too dry. For *xing* and *cao*, it should be a combination of dry and moist—moist to make it attractive and dry to avoid excessive novelty. When the ink is too thick, the brush will stick. When the ink is too dry, the stroke will be lifeless. These matters must not be ignored, either. The tip of the brush should be long, supple, and rounded. When it is long, it absorbs more ink and is free to move. When it is supple, it is firm and strong. When it is rounded, [the stroke] is attractive. I once argued that there are three things which differ in their use but are based on the same principle: When you draw a good bow, the arrow approaches you slowly; when you release it, it flies away swiftly. This is commonly called shooting the arrow. When you press a good knife blade, it bends; when you release it, it returns to its former state of being strong and straight. This is commonly called springiness. The tip of the brush should be the same. If after one stroke it stays bent and does not come back, how can it do what it is intended to do? Therefore, a long brush tip that is not springy is not as good as a shorter one. A springy brush tip that is not rounded is not as good as one that is not springy. Paper, brush, and ink are essential tools of calligraphy.

[7] Xing shu

I once investigated the *xing shu* of the Wei and Jin dynasties and found it to have a style of its own, different from the style of *cao shu*. It changed *zhen* just to adapt it to movement. *Cao* derived from *zhang*, and *xing* from *zhen*. Although they are different varieties all called *xing shu*, each has its distinct style. Yet the various Jin calligraphers were not very different from each other. *The Preface to the Orchid Pavilion Collection* and Wang Xizhi's other writings are at the top. Xie An and Wang Xianzhi are in second place. Among later calligraphers Yan Zhenqing, Liu Gongquan, Su Shi, and Mi Fu are also to be reckoned with.

Generally speaking, it is important that strokes be seasoned; then small mistakes can be compensated for. What matters is that heavy and light strokes alternate, like the rhythm of blood flowing through the veins within a firm, strong structure of sinews and bones. The style should be natural and unrestrained, the structure should be perfect, *zhen* should have the configuration of *zhen*, *xing* the configuration of *xing*, and *cao* the configuration of *cao*. Study should extend over a broad area; then all the various scripts can be mastered.

[8] Copying and Tracing

Tracing calligraphy is very easy. Tang Taizong said: "Let Wang Meng lie on your paper and let Xu Yan sit at the tip of your brush";[11] then you can mock Xiao Ziyun. Beginners must trace in order to control the hand and achieve results easily. It is imperative to place famous pieces of calligraphy by ancient masters on the desk and hang them to the right of the seat, to contemplate them all day long, pondering the principles of their brushstrokes. After that has been done, one is ready to trace or to copy. Next, the edges of each character should be outlined, traced on waxed paper very carefully without losing the beauty of the composition. In copying calligraphy, one easily loses the ancient masters' composition while acquiring much of their technique. In tracing, one easily captures the ancient masters' composition while losing much of their technique. By copying, one easily makes progress; by tracing, one easily forgets. The difference is between paying attention and not paying attention. In tracing, if one misses the smallest detail, the resulting spirit will be quite different [than if one had not missed it]. The important things are attention to detail and careful work.

More than several hundred copies of The Preface to the Orchid Pavilion Collection are extant today; the best is the Dingwu edition. But there are several different versions of the Dingwu edition. They are identical in regard to composition, length, and size, but they differ in the subtle details of being fat or thin, strong or soft, well made or clumsy, just as human faces differ. From this, one can know that the Dingwu edition, though engraved in stone, does not necessarily capture the true style of the original. Calligraphy depends entirely on the superiority of style. When carved in metal or stone, it must not be reproduced negligently. In tracing a character, the ink must not extend beyond the borders of the outline. In filling in the outline or putting cinnabar on the back of the paper, one must faithfully duplicate the thickness or thinness of the original. However, it is best to make [the character] a little thinner, because when the workers carve it and rub it smooth, the thin places will become a little thicker.

Some say that in tracing one should turn the model upside down; then there will be no admixture of the copyist's personal style. If the original copy is clear and the tracing paper is very thin, there is no harm in placing it upside down. If the original copy is not clear and the tracing paper is too thick, one needs an expert calligrapher to do the tracing, to bring out the spirit of the

11. This is from Tang Taizong's postscript to the biography of Wang Xizhi, Jin shu, 80.2108.

original. Points, corners, and hooks are the spirit of calligraphy. These will generally be largely lost in tracing. It is also necessary to pay careful attention to putting of cinnabar on the back of the tracing paper.

[9] Squareness and Roundness

Square and round strokes are used in *zhen* and *cao*. In *zhen*, square strokes are favored, and in *cao*, round strokes. In round strokes, it is best to have an admixture of squareness, and in square strokes, an admixture of roundness. But the combination of square, round, curved, and straight elements should not be too obvious; the elements should appear in a natural way. In *cao shu* it is even more so that horizontal and vertical strokes should not stand out clearly. When there are too many horizontal and vertical strokes, the calligraphy looks like a stack of firewood or a bundle of reeds and lacks the spirit of uninhibited expression. When they appear just occasionally, the effect is very good.

[10] Face to Face and Back to Back

Face to face and back to back is like people looking at, gesturing, saluting, and turning their backs on each other. When something is started on the left, there must be a response on the right; when something begins at the top, there must be a corresponding element below. Generally speaking, dots and lines must be structured and arranged with a rationale that applies to every one of them. When one looks for this among the ancients, [one finds that] Wang Xizhi was outstanding.

[11] Balance

When the lateral character components "standing" *ren* 人 [man], "raised" *tu* 土 [earth], *tian* 田 [field], *yu* 玉 [jade], *yi* 衣 [clothes] and *shi* 示 [show] are all made narrow and long, then there is extra space on the right side. It is the same with components forming the right sides of characters: they must not be too crowded or too cleverly made. Making them too crowded or too cleverly is a defect of the Tang calligraphers. When the element *kou* 口 [mouth] is on the left side, it must be even with [the top of] the right-hand element—for example, in *wu* 嗚 [alack], *hu* 呼 [alas], *hou* 喉 [throat], and *long* 嚨 [gullet]. When it is on the right, it must be even with the bottom [left-hand] side—for example, in *he* 和 [harmonious] and *kou* 扣

[knock]. Also, the top element mi ⌐ [lid] must completely cover what is below; the elements zou 走 [walk] and chuo 辶 [run] must hold up what is above. Their relative weight must be considered, so that they fit each other; their relative size must be considered, so that they balance each other. Such complementary proportions are praised as excellent.

[12] Looseness and Tightness

In calligraphy, looseness is considered good style, and tightness is considered a mark of experience. For example, in [making] the four horizontal strokes of jia 佳 [good], the three vertical strokes of chuan 川 [river], the four dots of yu 魚 [fish], and the nine horizontal strokes of hua 畫 [paint], it is best to write them strongly and calmly and with proper balance of looseness and tightness. When characters that should be loose are not written loosely, they look cramped. When characters that should be tight are not written tightly, the inevitable result is disintegration.

[13] Bearing

The first requirement for the bearing [of the characters] is a noble character [on the part of the calligrapher]; the second is modeling oneself on ancient masters; the third is good-quality brush and paper; the fourth is boldness and strength; the fifth is superb skill; the sixth is moist brightness; the seventh is a suitable internal balance; the eighth is occasional originality. When these requirements are met, long characters will look like neat gentlemen; short characters will be like strong and unyielding person; skinny characters will be like hermits living in mountains and marshes; fat characters will be like idle rich men; vigorous characters will be like warriors; handsome characters will be like beautiful women; slanting characters will be like intoxicated immortals; correct characters will be like gentlemen of high moral standing.

[14] Speed

Slow writing is good for achieving beauty; speed is good for achieving strength. One must first be able to write fast before one can write slowly. If one can never write fast and concentrates on writing slowly, there will be a lack of spirit. If one concentrates on writing fast, there will be much loss of vigor.

[15] Movement of the Brush

When the brush first comes down, one may let it run freely or one may bend the tip before continuing. The style of the whole character is determined by the first stroke. In any piece of calligraphy the first character is usually started with bent brush tip, whereas with the second character and the third the flow of the brush continues, usually because the brush is allowed to run freely. If there are mostly bent-tip strokes on the right side of a character, it is because they are in response to the left side. Also, there are strokes of even thickness, as with the strokes in li. A hidden brush tip is evident in zhuan [seal script]. Generally speaking, bent and free-running brush tips are good for holding something back. When all these techniques are combined, the result is perfection.

[16] Feeling and Temperament

Perfection of art is surely linked to spirit. For an exploration of this matter, see Han Yu's Essay to Gao Xian.[12] Sun Quanli says: "Because one writes at a given time, circumstances provide either discord or harmony. When there is harmony, the writing flows forth charmingly; when there is discord, it fades and scatters. Being happy in spirit and free from other duties is the first harmony. Having a feeling favorable to quick apprehension is the second harmony. Genial weather with the right amount of moisture in the air is the third harmony. A perfect match between paper and ink is the fourth harmony. An sudden, unsolicited desire to write is the fifth harmony. But a restless mind and a sluggish body constitute the first discord. An opposed will and constricted energy constitute the second discord. Dry wind and a hot sun constitute the third discord. A poor match between paper and ink constitutes the fourth discord. Exhausted emotions and a tired hand constitute the fifth discord. The distinction between discord and harmony is the difference between good and bad calligraphy."[13]

12. The essay, Song Gao Xian shangren xu, is extant today, see the Bibliography.

13. The Baichuan xuehai and Wang shi shuhua yuan editions insert here four other passages from Sun's Shu pu, introduced by the phrase "He also says." The first quotation begins with "Many different situations exist" and ends with "the thing to strive for is close resemblance." The second quotation begins with "Some are eager to be swift" and ends with "These are all people who go their own way and give in to their individual defects." The third quotation is the sentence "You must understand the use of dots and lines and make a broad study of the historical development of characters, absorb chong zhuan, and combine cao and li." The fourth

[17] Circulation of the Blood

In calligraphy a distinction is made between concealing and revealing the brush tip; this can be seen all over the page. It is best for the beginning and the end to correspond with each other and for the preceding and the following characters to be connected. Later students write outlines according to what they remember, without having absorbed [the strokes]. Their writing is disorganized and disconnected. [Wang Xizhi's] small-*kai* Yellow Court [Sutra] and his *Yue Yi Discourse* are different from each other. Also, his *Poem Praising Dongfang Shuo's Portrait* is unlike his *Preface to the Orchid Pavilion Collection*,[14] although in both cases the two pieces were written at the same time. Whenever he wrote something, the composition of his characters was different. This is the way it should be. I have contemplated the famous calligraphy of the ancients, and every piece has lively dots and lines, just as if I could see their brushes moving. Huang Tingjian says: "The brush in a piece of calligraphy is like the 'eye' in a Zen [Buddhist] saying."[15] This is quite true.

[18] *Writing with Cinnabar*

When the brush absorbs black ink, the strokes will be thin; when it absorbs red, the strokes will be thick. Therefore, in writing with cinnabar, thin characters are more highly prized, and there will always be an abundance of well-rounded and moist elegance; of dry vigor and robust age there can never be enough. This [effect] is produced by red cinnabar. If one wants the engravers not to lose the true essence, nothing is better than writing [directly on the surface] with cinnabar. But writing this way requires much energy and is very exhausting. Wei Dan climbed high up to write an inscription on the Lingyun Terrace. When he came down, his hair and beard had turned white. This is what is meant by not coming down until the artwork is finished. Men like Zhong You and Li Yong carved their own calligraphy [into stone] as a hobby.

quotation begins with "When identical strokes recur" and ends with "you can depart from Zhong You and Zhang Zhi and yet be successful." Following these four quotations there is a concluding statement: "His statements are quite apt; therefore I have quoted them in full."

14. On *The Poem Praising Dongfang Shuo's Portrait*, see Sun's *Treatise on Calligraphy*, n. 22, above. On *The Preface to the Orchid Pavilion Collection*, see ibid., n. 24.

15. See *Lun shu*, by Huang Tingjian, p. 355.

Shu pu

Autograph by Sun Qianli

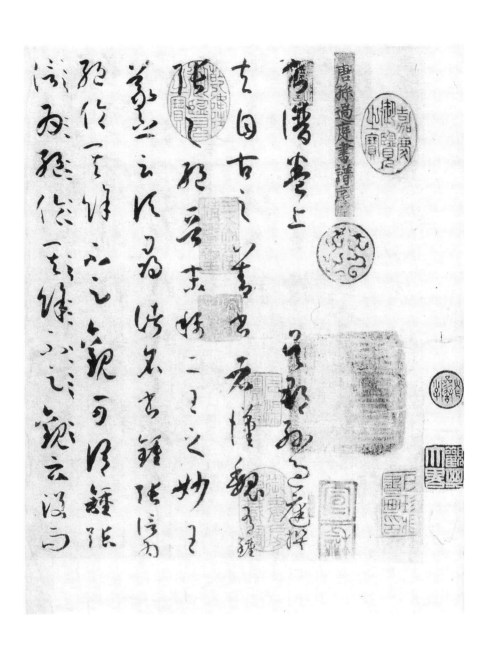

夫質以代興，妍因俗易。雖書契之作，適以記言，而淳醨一遷，質文三變，馳騖沿革，物理常然。貴能古不乖時，今不同弊，所謂文質彬彬，然後君子。何必易雕宮於穴處，反玉輅於椎輪者乎！

隆必孝諭安不顕及義之

士以而恬其蓺業以為

甲乎云嵩富貴其工物之妹

況衆子而又況阿人哉

而陶鈞以後壽折其以覺

摭像父之二已乎且立之物

名子資為履像母之墨誌

無不人以子豪翰之左右

云以雜体備于時，巧涉丹青，工虧翰墨，
之意及乎少妙，神怪之絕，
學之于心，難以方圓墨味，
亦猶弘羊之心，預乎無際，
時逾三紀，子敬入木之術，
百齡俟池之志，窺者無斜，
雲游之觀，容隱石之奇，
鴻飛獸駭之姿，鸞舞蛇驚，

之殊、絕岸頹峰之勢、臨危
據槁之形、或重若崩雲、
或輕如蟬翼、導之則泉注、
頓之則山安、纖纖乎似初月之出
天涯、落落乎猶眾星之列河
漢、同自然之妙有、非力運之
能成、信可謂智巧兼優、心手雙
暢、翰不虛動、下必有由

一畫之間，變起伏於鋒杪；

一點之內，殊衄挫於豪芒。況云

積其點畫乃成其字，暨

乎體勢，援玦義之由。合任筆

為礫，聚墨生形，杪之甚

方今當用奠意，而知

之姝妙，則二偶然，可以

扬雄谓：诗赋小道，壮夫不为。况复溺思毫厘，沦精翰墨者也。夫潜神对弈，犹标坐隐之名；乐志垂纶，尚体行藏之趣。詎若功宣礼乐，妙拟神仙，犹挻埴之罔穷，与工炉而并运。好异尚奇之士，玩体势之多方

之玄甚日撝擬之奧慘美盡

言俯之標軸藻鑒者在乎

善必愈固縈明之心不以

嘗達之魚畫畫精窗

嘗當況然之此情真別方樹

情不一足爵棄此詠游我別

而東亦士人互而陶渡之作

王褉之於卻廊之作於紙書

之神奇，咸亦挹其風味。去之滋永，斯道逾微。方復聞疑稱疑，得末行末，古今阻絕，無所質問；設有所會，緘祕已深，遂令學者茫然，莫知領要，徒見成功之美，不悟所致之由。或乃就分布於累年，向規矩而猶遠，圖

若思通楷則，少不如老；學成規矩，老不如少。思則老而逾妙，學乃少而可勉。勉之不已，抑有三時；時然一變，極其分矣。至如初學分布，但求平正；既知平正，務追險絕；既能險絕，復歸平正。初謂未及，中則過之，後乃通會。通會之際，人書俱老。

真以點畫為形質，使轉為情性；草以點畫為性情，使轉為形質。草乖使轉，不能成字；真虧點畫，猶可記文。回互雖殊，大體相涉。故亦旁通二篆，俯貫八分，包括篇章，涵泳飛白。

至如鍾繇隸奇，張芝草聖，此乃專精一體，以致絕倫。伯英不真，而點畫狼藉；元常不草，使轉縱橫。自茲已降，不能兼善者，有所不逮，非專精也。

各攸宜。篆尚婉而通，隸欲精而密，草貴流而暢，章務檢而便。然後凜之以風神，溫之以妍潤，鼓之以枯勁，和之以閑雅。故可達其情性，形其哀樂。驗燥濕之殊節，千古依然；體老壯之異時，百齡俄頃。嗟乎，不入其門，詎窺其奧者也。

一時而書，有乖有合，合則流媚，乖則彫疏，略言其由，各有其五：神怡務閑，一合也；感惠徇知，二合也；時和氣潤，三合也；紙墨相發，四合也；偶然欲書，五合也。心遽體留，一乖也；意違勢屈，二乖也；風燥日炎，三乖也；紙墨不

紙墨不稱四乖也情怠手闌五乖也乖合之際優劣互差得時不如得器得器不如得志若五乖同萃思遏手蒙五合交臻神融筆暢暢無不適蒙無所從當仁者得意忘言罕陳其要企學者希風敘妙雖述猶疏

书谱（草书）

貴能古不乖時，今不同弊，所謂文質彬彬，然後君子。何必易雕宮於穴處，反玉輅於椎輪者乎！

又云：子敬之不及逸少，猶逸少之不及鍾張。意者以為評得其綱紀，而未詳其始卒也。且元常專工於隸書，伯英尤精於草體，彼之二美，而逸少兼之。擬草則餘真，比真則長草，雖專工小劣，而博涉多優；總其終始，匪無乃可。謝安素善尺牘，而輕子敬之書。

名氏流播，遂欲附贗，士大夫以傳授，才情余合。
一源派別，附託便爾，傳搜秘而畫殘，笑傲而輕貌。
無加以摩壑，不傳搜秘，偶興殘賞，孫輕之貌。
少當代貴之，見其書跡，揚自標先，風規自遠。

六文之化肇自羲軒庶柱八辨之
與好於巖谷云之來為亨廉
用羽功但已古不同姝頁理
陽為机仁豎又之州清任了
新地雲面涪之濤兔野光英
之巖已園本於南未戈安淌
於當矛乃浮丹書三罰蜀
墨態堂下松戈姓任淳等代

傳芳飐飐之子藉甚筆勢隔行十一

文邃理諭之業者松傍者有

玩絕妙古軍旦古軍位重

古高周淸詞遐聲共派殊

橫仍暑寬之致一古凝一子

若以之隨程古詩老子眼

漲兮翻其叶義方二子皆

執鬯一遑松比最弟飲歲

又云之者但英同學彼乃

更亲意延若摭儒末但英

和用照之取義通摭此

以筆世潘信詞英

而信為此之久以凍教

庶但古軍之代為勝香食

可摭而不言摭信若呼

云古通人之乃情深周

漢末伯英下少一百六十餘字

卷可明

論非

禪學

夫芸擒日廣積以臻其

致退善不多沧於

陸而孤秖此一二哉而風

味言一字由昭陈焉乃以宗

殺信黄唯强弦方扬盡

濆夫陽蕭累言李少章

共擒又學芸民信仁信

無乃羽羽考伏言不蔽

神怡務閑，一合也；感惠徇知，二合也；時和氣潤，三合也；紙墨相發，四合也；偶然欲書，五合也。心遽體留，一乖也；意違勢屈，二乖也；風燥日炎，三乖也；紙墨不稱，四乖也；情怠手闌，五乖也。乖合之際，優劣互差。得時不如得器，得器不如得志，若五乖同萃，思遏手蒙；五合交臻，神融筆暢。暢無不適，蒙無所從。

文雅之日數度為成
如逸群林以至不須名而絕
專分運當情動取
臨言風殊之意陽靜
恬手乎地之花
情相並原
然子證本周之方
由己出規復作

初謂未及，中則過之，後乃通會，通會之際，人書俱老。仲尼云：五十知命，七十從心，故以達夷險之情，體權變之道，亦猶謀而後動，動不失宜；時然後言，言必中理矣。是以右軍之書，末年多妙，當緣思慮通審，志氣和平，不激不厲，而風規自遠。

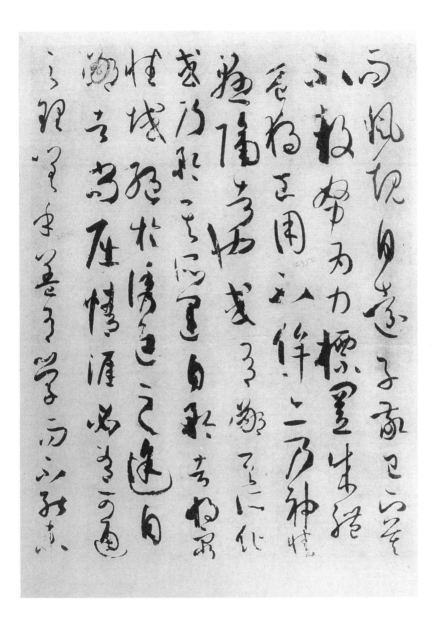

之弦出規之辨貫井之
淺己所言識鋭其措矣
蓋有託於譲讓然播當
達之自杜御其心得習
之掌託小悟一言乎摩
後百酒出向壺小弥之患
瓢改至手而惠專松
逸之懷達而右矣云之致

張弛，不有老成，鮮克

臻會。譬夫絳樹青琴，殊姿共艷；

隨珠和璧，異質同妍。何必

刻鶴圖龍，竟慚真體；

得魚獲兔，猶恡筌蹄。聞夫

家有南威之容，乃可論於淑媛；

有龍泉之利，然後議於

斷割。語過其分，實累樞機。

吾嘗盡思作書，謂為甚合，時稱識

者，輒以引示。其中巧麗，曾不

留目；頃見

偏工，或寫其

所偏。

心昏擬效之方，手迷揮運之理，求其妍妙，不亦謬哉！然君子立身，務修其本。揚雄謂：詩賦小道，壯夫不為。況復溺思毫釐，淪精翰墨者也。

転精熟規矩諳於胸襟
自然容與徘徊意先筆後
瀟灑流落翰逸神飛
亦猶弘羊之心預乎無際
庖丁之目不見全牛
嘗有好事就吾求習
吾乃粗舉綱要隨而授之
無不心悟手從言忘意得
爰有道之情愉愉然如得
至寶之情悟之於心妙思之理

至若數畫並施，其形各異；眾點齊列，為體互乖。一點成一字之規，一字乃終篇之準。違而不犯，和而不同，留不常遲，遣不恒疾；帶燥方潤，將濃遂枯；泯規矩於方圓，遁鉤繩之曲直

睡芳月芳花家衣於之

情調通於弦上樂留心

三懷特另自有象數而

世先生達鍾作而為三雲坤

樹書理雅其龍隱涉如

鷹吳歡同姸日必則鄣圓

乾克巫其溺日魚飲兔北

稜望涉由之家务南威

乙宮乃以此於污嫒子子
能泉之乃在後漾於新
寂漂色そ分之兴推揉
至葛盡四化出污而古言時
杨滚丢孤所引示言中竹
忽曾不曾回我子归生
忽被望之是哦以见老怅
以神我以手群自高耶

淺深未乃傾之以流蕩

之以古目馬矣志及意

玄馳騖沿革貴能古不

華儀謙諭之生能固

以之嫺儒以葉必之懷

完石伯子之亞涼波差

因是之蒸蒸以宗夢孫

玄湮

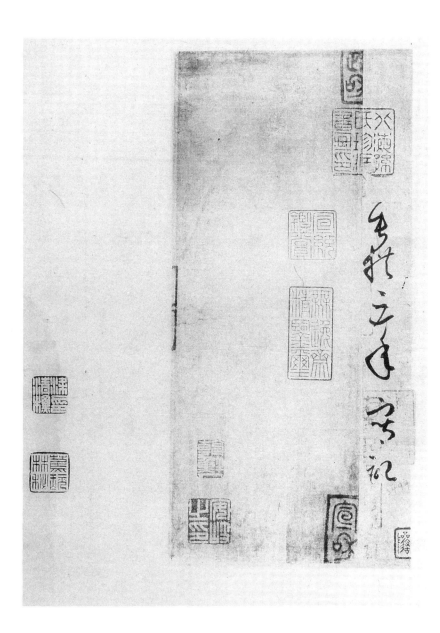

Shu pu

Transcription by Chang Ch'ung-ho

書譜　　　　　　孫過庭撰

夫自古之善書者，漢、魏有鍾、張之絕，晉末稱二王之妙。王羲之云：「頃尋諸名書，鍾、張信為絕倫，其餘不足觀。」可謂鍾、張云沒，而羲、獻繼之。又云：「吾書比之鍾、張：鍾當抗行，或謂過之。張草猶當雁行，然張精熟，池水盡墨，假令寡人耽之若此，未必謝之。」此乃推張邁鍾之意也。攷其專擅，雖未果於前規；摭以兼通，故無慊於即事。評者云：「彼之四賢，古今特絕；而今不逮古，古質而今妍。」夫質以代興，妍因俗易。雖書契之作，適以記言；而淳醨一遷，質文三變，馳騖沿革，

物理常然。貴骸古不乘時，今不同弊，所謂「文質彬彬，
然後君子。」何必易雕宮於穴處，反玉輅於椎輪者乎！又
云：「子敬之不及逸少，猶逸少之不及鍾張。」意者以為評
得其綱紀，而未詳其始卒也。且元常專工於隸書，伯英
尤精於草體；彼之二美，而逸少兼之：擬草則餘真，比
真則長草，雖專工小劣，而博涉多優，總其終始，匪無
乘互。謝安素善尺牘，而輕子敬之書。子敬嘗作佳書與
之，謂必存錄，安輒題後答之，甚以為恨。安嘗問敬：
「卿書何如右軍？」答云：「故當勝。」安云：「物論殊不爾。」子
敬又答：「時人那得知！」敬雖權以此辭，折安所鑒，自稱

勝父，不亦過乎！且立身揚名，事資尊顯，勝母之里，曾參不入。以子敬之豪翰，紹右軍之筆札，雖復粗傳楷則，實恐未克箕裘。況乃假託神仙，恥崇家範，以斯成學，孰愈面牆！後義之注都，臨行題壁。子敬密拭除之，輒書易其處，私為不惡。義之還見，乃歎曰：「吾去時真大醉也。」敬乃內慙。是知逸少之比鍾張，則專博斯別；子敬之不及逸少，無或疑焉。余志學之年，留心翰墨，味鍾張之餘烈，挹義獻之前規，極慮專精，時逾二紀，有乖入木之術，無間臨池之志。觀夫懸針垂露之異，奔雷墜石之奇，鴻飛獸駭之資按資應作姿，鸞舞蛇驚之態，

絕岸頹峯之勢，臨危據槁之形；或重若崩雲，或輕如蟬翼；導之則泉注，頓之則山安；纖纖乎似初月之出天崖，落落乎猶眾星之列河漢；同自然之妙有，非力運之能成；信可謂智巧兼優，心手雙暢；翰不虛動，下必有由：一畫之間，變起伏於峯杪；一點之內，殊衄挫於豪芒。況云積其點畫，乃成其字；曾不傍窺尺牘，俯習寸陰；引班超以為辭，援項籍而自滿；任筆為體，聚墨成形；心昏擬效之方，手迷揮運之理：求其研妙，不亦謬哉！然君子立身，務修其本，揚雄謂詩賦小道，壯夫不為，況復溺思豪釐，淪精翰墨者也。夫潛神對弈，猶標坐隱

之名；樂志垂綸，尚體行藏之趣。詎若功宣禮樂，妙擬
神仙，猶挺埴之罔窮，與工鑪而並運。好異尚奇之士，
翫體勢之多方；窮微測妙之夫，得推移之奧賾。著述者
假其糟粕，藻鑒者挹其菁華，固義理之會歸，信賢達之
兼善者矣。存精寓賞，豈徒然與！而東晉士人，互相陶
淬。至於王謝之族，郗庾之倫，縱不盡其神奇，咸亦挹
其風味。去之滋永，斯道逾微。方復聞疑稱疑，得末行
末；古今阻絕，無所質問；設有所會，緘祕已深；遂令
學者茫然，莫知領要，徒見成功之美，不悟所致之由。
或乃就分布於累年，向規矩而猶遠，圖真不悟，習草將

迷。假令薄解草書，粗傳隸法，則好溺偏固，自閡通規

。詎知心手會歸，若同源而異派；轉用之術，猶共樹而

分條者乎？加以趨變適時，行書為要；題勒方幅，真乃

居先。草不兼真，殆於專謹；真不通草，殊非翰札。真

以點畫為形質，使轉為情性；草以點畫為情性，使轉為

形質。草乖使轉，不能成字；真虧點畫，猶可記文。迴

互雖殊，大體相涉。故亦傍通二篆，俯貫八分，包括篇

章，涵泳飛白。若豪釐不察，則胡越殊風者焉。至如鍾

繇隸奇，張芝草聖，此乃專精一體，以致絕倫。伯英不

真，而點畫狼藉，元常不草，而使轉縱橫。自茲以降，

不能兼善者，有所不逮，非專精也。雖篆隸草章，工用

多變；濟成厥美，各有攸宜：篆尚婉而通，隸欲精而密

，草貴流而暢，章務檢而便。然後凜之以風神，溫之以

妍潤，鼓之以枯勁，和之以閑雅。故可達其情性，形其

哀樂。驗燥濕之殊節，千古依然；體老壯之異時，百齡

俄頃。嗟乎，不入其門，詎窺其奧者也！又一時而書有

乘有合，合則流媚，乖則彫疎，略言其由，各有其五：

神怡務閑，一合也；感惠徇知，二合也；時和氣潤，三合

也；紙墨相發，四合也；偶然欲書，五合也。心遽體留

，一乘也；意違勢屈，二乘也；風燥日炎，三乖也；紙

墨不稱，四乖也；情怠手闌，五乖也。乖合之際，優劣
互差。得時不如得器，得器不如得志。若五乖同萃，思
遏手蒙；五合交臻，神融筆暢。暢無不適，蒙無所從。
當仁者得意忘言，罕陳其要；企學者希風敘妙，雖述猶
疏。達攷其工，未敷厥旨。不揆庸昧，輒效所明，庶欲
弘既往之風規，導將来之器識，除繁去濫，覩迹明心者
焉。代有筆陣圖七行，中畫執筆三手，圖貌乖舛，點畫
湮訛。頃見南北流傳，疑是右軍所製。雖則未詳真偽，
尚可發啟童蒙。既常俗所存，不藉編錄。至於諸家勢評，
，多涉浮華，莫不外狀其形，内迷其理，今之所撰，亦

無取焉。若乃師宜官之高名，徒彰史牒；邯鄲淳之令範，空著縑緗。暨乎崔、杜以來，蕭、羊已往，代祀綿遠，名氏滋繁。或籍甚不渝，人亡業顯；或憑附增價，身謝道衰。加以糜蠹不傳，搜祕將盡，偶逢鑒賞，時亦罕窺，優劣紛紜，殆難觀縷。其有顯聞當代，遺跡見存，無俟抑揚，自標先後。且六文之作，肇自軒轅；八體之興，始於嬴政。其來尚矣，厥用斯宏。但今古不同，妍質懸隔，既非所習，又亦略諸。後有龍蛇雲露之流，龜鶴花英之類，乍圖真於率爾，或寫瑞於當年，巧涉丹青，工虧翰墨，異夫楷式，非所詳焉。代傳羲之與子敬筆

勢論十章，文鄙理疏，意乖言拙，詳其旨趣，殊非右軍

。且右軍位重才高，調清詞雅，聲塵未泯，翰牘仍存。

觀夫致一書，陳一事，造次之際，稽古斯在；豈有貽謀

令嗣，道叶義方，章則頓虧，一至於此！又云與張伯英

同學，斯乃更彰虛誕。若指漢末伯英，時代全不相接；

必有晉人同號，史傳何其寂寥！非訓非經，宜從棄擇。

夫心之所達，不易盡於名言；言之所通，尚難形於紙墨

。粗可髣髴其狀，綱紀其辭。冀酌希夷，取會佳境。闕

而未逮，請俟將來。今撰執、使、轉、用之由，以祛未

悟：執謂淺深長短之類是也；使謂縱橫牽掣之類是也；

轉謂鈎鐶盤紆之類是也；用謂點畫向背之類是也。方復會其數洗，歸於一途；編列眾工，錯綜羣妙；舉前賢之未及，啟後學於成規；窮其根源，析其枝派。貴使文約理贍，跡顯心通；披卷可明，下筆無滯。詭辭異說，非所詳焉。然今之所陳，務裨學者。但右軍之書，代多稱習，良可據為宗匠，取立指歸。豈唯會古通令，亦乃情深調合。致使摹搨日廣，研習歲滋；先後著名，多從散落；歷代孤紹，非其效與？試言其由，略陳數意：止如樂毅論、黃庭經、東方朔畫讚、太師箴、蘭亭集序、告誓文，斯並代俗所傳，真行絕致者也。寫樂毅則情多怫鬱

；書畫讚則意涉瑰奇；黃庭經則怡懌虛無；太師箴又縱橫爭折；暨乎蘭亭興集，思逸神超；私門誡誓，情拘志惨。所謂涉樂方笑，言哀已歎。豈惟駐想流波，將貼嘩嘆之奏；馳神睢渙，方思藻繪之文。雖其目擊道存，尚或心迷議舛。莫不殊名為體，共習分區。豈知情動形言，取會風騷之意；陽舒陰慘，本乎天地之心。既失其情，理乖其實，原夫所致，安有體哉！夫運用之方，雖由己出，規模所設，信屬目前，差之一豪，失之千里，苟知其術，適可兼通。心不厭精，手不忘熟。若運用盡於精熟，規矩諳於胸襟，自然容與徘徊，意先筆後，瀟洒

流落，翰逸神飛。亦猶弘羊之心，豫乎無際；庖丁之目
，不見全牛。嘗有好事，就吾求習，吾乃應麾舉綱要，隨
而授之，無不心悟手從，言忘意得；縱未窮於眾術，斷
可極於所詣矣。若思通楷則，少不如老；學成規矩，老
不如少。思則老而逾妙，學乃少而可勉。勉之不已，抑
有三時：時然一變，極其分矣。至如初學分布，但求平
正；既知平正，務追險絕；既能險絕，復歸平正。初謂
未及，中則過之，後乃通會。通會之際，人書俱老。仲
尼云：五十知命也，七十從心。故以達夷險之情，體權
變之道。亦猶謀而後動，動不失宜；時然後言，言必中

理。是以右軍之書，末年多妙，當緣思慮通審，志氣和平，不激不厲，而風規自遠。子敬已下，莫不鼓努為力，標置成體，豈獨工用不侔，亦乃神情懸隔者也。或有鄙其所作，或乃矜其所運。自矜者將窮性域，絕於誘進之途；自鄙者尚屈情涯，必有可通之理。嗟乎，蓋有學而不能，未有不學而能者也。考之即事，斷可明焉。然消息多方，性情不一，乍剛柔以合體，忽勞逸而分驅：或恬淡雍容，內涵筋骨；或折挫槎枿，外曜峰芒。察之者尚精，擬之者貴似。況擬不能似，察不能精；分布猶疏，形骸未檢；躍泉之態未覩其妍，窺井之談已聞其醜

。縱欲搪突羲獻，誣罔鍾張，安能掩當年之目，杜將來

之口！慕習之輩，尤宜慎諸。至有未悟淹留，偏追勁疾

；不能迅速，翻效遲重。夫勁速者，超逸之機；遲留者

，賞會之致。將返其速，行臻會美之方；專溺於遲，終

爽絕倫之妙。能速不速，所謂淹留；因遲就遲，詎名賞

會！非夫心閑手敏，難以兼通者焉。假令眾妙攸歸，務

存骨氣；骨既存矣，而遒潤加之。亦猶枝幹扶疏，凌霜

雪而彌勁；花葉鮮茂，與雲日而相暉。如其骨力偏多，

遒麗蓋少，則若枯槎架險，巨石當路，雖妍媚云闕，而

體質存焉。若遒麗居優，骨氣將劣，譬夫芳林落蕊，空

照灼而無依，蘭沼漂萍，遠青翠而奚託。是知偏工易就

，盡善難求。雖學宗一家，而變成多體，莫不隨其性欲

，便以為姿；質直者則徑侹不遒；剛很者又崛強無潤，

矜斂者弊於拘束；脫易者失於規矩，溫柔者傷於軟緩，

躁勇者過於剽迫；狐疑者溺於滯澀，遲重者終於蹇鈍；

輕瑣者染於俗吏。斯皆獨行之士，偏玩所乖。易曰：「觀

乎天文，以察時變；觀乎人文，以化成天下。」況書之為

妙，近取諸身。假令運用末周，尚虧工於秘奧；而波瀾

之際，已濬發於靈台。必能傍通點畫之情，博究始終之

理，鎔鑄蟲篆，陶均草隸。體五材之並用，儀形不極，

像八音之迭起，感會無方。至若數畫並施，其形各異；眾點齊列，為體互乖。一點成一字之規，一字乃終篇之準。違而不犯，和而不同；留不常遲，遣不恆疾；帶燥方潤，將濃遂枯；泯規矩於方圓，遁鉤繩之曲直；乍顯乍晦，若行若藏；窮變態於毫端，合情調於紙上；無間心手，忘懷楷則：自可背羲獻而無失，違鍾張而尚工。譬夫絳樹青琴，殊姿共艷；隋珠和璧，異質同妍。何必刻鶴圖龍，竟慚真體；得魚獲兔，猶恡筌蹄。聞夫家有南威之容，乃可論於淑媛：有龍泉之利，然後議於斷割，語過其分，實累樞機。吾嘗盡思作書，謂為甚合，時

稱識者，輒以引示：其中巧麗，曾不留目；或有誤失，翻被嗟賞。豈昧所見，尢喻所聞。或以年職自高，輕致陵誚。余乃假之以緗縹，題之以古目；則賢者改觀，愚夫繼聲，競賞豪末之奇，罕議峰端之失；猶惠侯之好偽，似葉公之懼真。是知伯子之息流波，蓋有由矣。夫蔡邕不謬賞，孫陽不妄顧者，以其玄鑒精通，故不滯於耳目也。向使奇音在爨，庸聽驚其妙響；逸足伏櫪，凡識知其絕羣，則伯喈不足稱，良樂未可尚也。至若老姥遇題扇，初怨而後請；門生獲書几，父削而子懊；知與不知也。夫士，屈於不知己，而伸於知己；彼不知也，曷足

怪乎！故莊子曰：朝菌不知晦朔，蟪蛄不知春秋。老子

云：下士聞道，大笑之；不笑之則不足以為道也。豈可

執冰而咎夏虫哉！自漢魏已來，論書者多矣，妍蚩雜糅

，條目糾紛：或重述舊章，了不殊於既注；或苟興新說

，竟無益於將來；徒使繁者彌繁，闕者仍闕。今撰為六

篇，分成兩卷，第其工用，名曰書譜。庶使一家後進，

奉以規模；四海知音，或存觀省，緘祕之旨，余無取焉

。

垂拱三年寫記

一九九四年六月十四日攄朱建新孫過庭書譜

箋證本鈔　　克和於美東康州北港

Xu shu pu, with Variants

Transcription by Chang Ch'ung-ho

續書譜

〔二〕 總論

真行草書之法，其源出于虫篆、八分、飛白、章草等。
圓勁古澹，則出于虫篆；點画波發，則出于八分；轉換
向背，則出于飛白；簡便痛快，則出于章草。然而真草
與行，各有體制。歐陽率更、顏平原輩以真為草，李邕[1]
、西台輩[2]以行為真，亦以古人有專工正書者，有專工草
書者，有專工行書者，信乎其不能兼美也。或云，草書
千字[3]，不抵行書[4]十字；行書[5]十字，不如真書一字。意以
為草至易而真至難，豈真知書者哉！大抵下筆之際，盡
仿古人，則少神氣；專務遒勁，則俗病不除。所貴熟習

精通，心手相應，斯為美矣。白雲先生、歐陽率更書訣

亦能言其梗概，孫過庭論之又詳，可參稽之。

【三】真書

真書以平正為善，此世俗之論，唐人之失也。古今真書

之神妙，無出鍾元常，其次則王逸少。今觀二家之書，

皆瀟洒縱橫，何拘平正？良由唐人以書判取士，而士大

夫字書，類有科舉習氣。顏魯公作《干祿字書》，是其證也

，知歐、虞、顏、柳，前後相望，故唐人下筆，應規入

矩，無復魏晉飄逸之氣。且字之長短、大小、斜正、疏

密，天然不齊，孰能一之？謂如東字之長，西字之短，

「口」字之小，「體」字之大，「朋」字之斜，「黨」字之正，「千」字之疏

，「萬」字之密，畫多者宜瘦，火者宜肥[17]，魏晉書法之高，良由各盡字之真態，不以私意參之耳。或者專喜方已，極意歐、顏；或者惟務勻圓，專師虞、永。或謂體須稍[18][19][20]匾，則自然平正，此又有徐會稽之病。或云欲其蕭散，則自不塵俗，此又有王子敬之風。豈足以盡書法之美哉！真書用筆，自有八法，吾嘗採古人之字，列之以為圖[21]，令略言其指：點者，字之眉目，全藉顧眄精神。有向[22]有背，隨字異形。橫直畫者，字之體骨[23]，欲其堅正勻靜，有起有止，所貴長短合宜，結束堅實。 丿 音佛。〕者，字之手足，伸縮異度，變化多端，要如象翼鳥[24]趐，有偏；自得之狀。」挑剔者，字之步履，欲其沉實。晉人挑剔或帶斜拂，或橫引向外，至顏、柳始正鋒為

音髻。

音拂。

音髻。

之，正鋒則無飄逸之氣。轉折者，方圓之法，真多用折

，草多用轉。折欲少駐，駐則有力；轉不欲滯，滯則不

遒。然而真以轉而後遒[26]，草以折而後勁，不可不知也。

懸針者，筆欲極正，自上而下，端若引繩。若垂而復縮

，謂之垂露。故翟伯壽問于米老曰：「書法當何如[28]。」米老

曰：「無乖不縮，無注不收。」此必至精至熟，然後能之。

古人遺墨，得其一點一畫，皆昭然絕異者，以其用筆精

妙故也。大令以來，用筆多失[29]，一字之間，長短相補，

斜正相�!，肥瘦相混，求妍媚于成體之後，至于令尤甚

焉[30]。

〔三〕 用筆

用筆不欲太肥，肥則形濁；又不欲太瘦，瘦則形枯；不

欲多露鋒芒，露則意不持重；不欲深藏圭角，藏則體不[31]
精神；不欲上大下小[33]，不欲左高右低[34]，不欲前多後少。[32]
歐陽率更結體太拘[36]，而用筆特備眾美，雖小楷而翰墨洒[35]
落，追踪鍾、王，來者不能及也[38]。顏、柳結體既異古人[37]
，用筆復溺于一偏，予評二家為書法之一變。數百年間[39]
，人爭效之，字畫剛勁高明，固不為書法之無助[40]，而晉
、魏之風軌，則埽地矣。然柳氏大字，偏旁清勁可喜，[41][42]
更為奇妙。近世亦有仿效之者，則俗濁不除[44]，不足觀。[43]
故知與其太肥，不若瘦硬也。

（四）草書[45]

草書之體，如人坐臥行立、揖遜忿爭、乘舟躍馬、歌舞

擗踴，一切變態，非苟然者。又一字之體，率有多變，有趣有應，如此趣者，當如此應。各有義理。右軍書「義[46]之字、當字、得字[47]、慰字最多，多至數十字，無有同者，而未嘗不同也，可謂所欲不逾矩矣。大凡學草書，先當取法張芝、皇象、索靖章草等[48]，則結體平正，下筆有源。然後仿王右軍，申之以變化，鼓之以奇崛。若泛學諸家，則字有工拙，筆多失誤，當連者反斷，當斷者反續，不識向背，不知趣止，不悟轉換；隨意用筆，任筆賦形，失誤顛錯，反為新奇。自大令以來，巳如此矣，況今世哉！然而襟韻不高，記憶雖多，莫滴塵俗。若風[49]神蕭散，下筆便當過人。自唐以前多是獨草，不過兩字屬連。累數十字而不斷，號曰連綿、游絲，此雖出于古

人，不足為奇，更成大病。古人作草，如今人作真，何
嘗茍且。其相連處，特是引帶。嘗攷其字，是點畫處皆
重，非點畫處偶相引帶，其筆皆輕。雖復變化多端，而
未嘗亂其涂度。張顛、懷素規矩最猈野逸，而不失此法
50
。近代山谷老人，自謂得長沙三昧，草書之法，至是又
51
一變矣。流至于今，不可復觀。唐太宗云：「行、若縈春
蚓，字：如縮秋蛇。」惡無骨也。大抵用筆有緩有急，有
有鋒，有無鋒，有承接上文，有牽引下字，乍徐還疾，
忽注復收。緩以效古，急以出奇；有鋒以耀其精神，無
鋒以含其氣味：橫斜曲直，鈎環盤紆，皆以勢為主。然
53
不欲相帶，帶則近俗；橫畫不欲太長，長則轉換遲；直
54
畫不欲太多，多則神癡。以捺代乀以發代辵，辵亦以捺
52

代[55]，惟ノ則間用之。意盡則用懸針，意未盡須再生筆意[56]

，不若用垂露耳。

[五] 用筆

用筆如折釵股，如屋漏痕，如錐畫沙，如壁坼。此皆後
人之論[60]，折釵股[57]欲其曲[58]折圓而有力；屋漏痕[59]欲其橫直勻
而藏鋒；錐畫沙[61]欲其無起止之迹[62]；壁坼者，欲其無布置
之巧。然皆不必若是，筆正則鋒藏[63]，筆偃則鋒出，一起
一倒，一晦一明[64]，而神奇出焉。常欲筆鋒在畫中，則左
右皆無病矣。故一點一畫，皆有三轉；一波一拂[65]，皆有
三折；一ノ又有数樣[66]。一點者欲與畫相應，兩點者欲自
相應；三點者必有一點起，一點帶，一點應；四點者一

恕、兩帶、一應。《筆陣圖》云：「若平直相似，狀如算子，便不是書。」如口，音圍。當行草時，尤宜泯其棱角，以寬閑圓美為佳。「心正則筆正」，「意在筆前，字居心後，皆名言也。故不得中行，與其工也寧拙，與其弱也寧勁，與其鈍也寧速。然極須淘洗俗姿，則妙處自見矣。大抵要執之欲緊，運之欲活，不可以指運筆，當以腕運筆。執之在手，手不主運；運之在腕，腕不主執。又作字者，亦須略孜篆文，須知點畫來歷先後，如「左」、「右」之不同，「刺」、「刺」之相異，「王」之與「玉」，「示」之與「衣」，以至「奉」、「秦」、「泰」、「春」，形同體殊，得其源本，斯不浮矣。孫過庭有執、使、轉、用之法：執為長短淺深，使為縱橫牽掣，轉為鉤環盤紆，用為點畫向背。豈苟然哉！

〔六〕用墨

凡作楷[81]，墨欲乾[82]，然不可太燥。行草則燥潤相雜，以潤[83]取妍，以燥取險。墨濃則筆滯，燥則筆枯，亦不可不知也。筆欲鋒長勁而圓[86]，圓則妍美。予嘗評世有三物，用不同而理相似：良弓引之則緩來[87]，舍之則急注，世俗謂之揭箭削；好刀按之則曲，舍之則勁直如初，世俗謂之回性；筆鋒亦欲如此，若一引之後，已曲不復挺[88]，又安能如人意耶，故長而不勁，不如弗長[89]；勁而不圓，不如弗勁[90]。紙筆墨皆[91]書法之助也。

〔七〕 行書

嘗夷攷魏、晋行書，自有一體，與草書不同。大率變真，以便于揮運而已。草出于章，行出于真，雖曰行書，各有其體。縱復晋代諸賢，亦不相遠。《蘭亭記》及右軍諸帖第一，謝安石、大令諸帖次之，顏、柳、蘇、米，冰後世必可觀者。大要以筆老為貴，少有失誤，亦可輝映。所貴乎穠纖間出，血脉相連，筋骨老健，風神洒落，姿態備具，真有真之態度，行有行之態度，草有草之態度。必須博學，可以兼通。

〔八〕 臨摹

摹書最易，唐太宗云：「臥王濛于紙中，坐徐偃于筆下」，

亦可以嗤蕭子雲。唯初學書者不得不摹，亦以節度其手，

易于成就。皆須是古人名筆，置之几案，懸之座右，朝

夕諦觀，思其用筆之理，然後可以摹臨。其次雙鈎蠟本

，須精意摹拓，乃不失位置之美耳。臨書易失古人位置

，而多得古人筆意；摹書易得古人位置，而多失古人筆

意。臨書易進，摹書易忘，經意與不經意也。夫臨摹之

際，毫髮失真，則神情頓異，所貴詳謹。世所有《蘭亭》，

何啻數百本，而定武為最佳。然定武本有數樣，今取諸

本參之，其位置、長短、大小，無不一同，而肥瘠、剛

柔、工拙要妙之處，如人之面，無有同者。以此知定武

雖石刻，又未必得真跡之風神矣。字書全以風神超邁為

主，刻之金石，其可苟哉！雙鈎之法，須得墨暈不出字

外，或廓填其内，或朱其背，已得肥瘦之本體。雖然，[103]

尤貴于瘦，使工人刻之，又逐而刮治之，則瘦者亦變為

肥矣。或云雙鈎時須倒置之，[104]則亦無容私意于其間。誠

使下本明，上紙薄，倒鈎何害？若下本晦，上紙厚，卻

須能書者為之，發其筆意可也。夫鋒芒圭角，字之精神

，大抵雙鈎多失，此又須朱其背時，稍致意焉。

〔九〕方圓

方圓者，真草之體用。真貴方，草貴圓。方者參之以圓[105]

圓者參之以方，斯為妙矣。然而方圓、曲直，不可顯

露，直須涵泳一出于自然。如草書尤忌橫直分明，橫直[106]

多則字有積薪、束葦之狀，而無蕭散之氣。時參出之[107]

斯為妙矣。

〔十一〕　向背[108]

向背者，如人之顧盼、指畫、相揖、相背。發于左者應
于右，起于上者伏于下。大要點畫之間，施設各有情理
，求之古人，右軍蓋為獨步。[109]

〔十二〕　位置

假如立人、挑土、「田」、「王」、「衣」、「示」，一切偏旁皆須令狹
長，則右有餘地矣。在右者亦然，不可太密、太巧。太
密、太巧者，[110]是唐人之病也。假如「口」字，在左者皆須與
上齊，「鳴」、「呼」、「喉」、「嚨」等字[111]是也；在右者皆須與下齊，

善。

「和」、「扣」等是也。又如「頭須令覆其下，「走」、「廴」皆須能承其上。審量其輕重，使相負荷，計其大小，使相副稱為善。

〔十二〕 疏密

書以疏欲風神，密欲老氣。如「佳」之四橫、「川」之三直、「魚」之四點、「畫」之九畫，必須下筆勁淨，疏密停勻為佳，當疏不疏，反成寒乞；當密不密，必至彫疏。

〔十三〕 風神

風神者，一須人品高，二須師法古，三須筆紙佳，四須險勁，五須高朗，六須潤澤，七須向背得宜，八須時出

新意。自然長者如秀整之士，短者如精悍之徒，瘦者如山澤之癯，肥者如貴游之子，勁者如武夫，媚者如美女，攲斜如醉仙，端楷如賢士。

〔十四〕遲速

遲以取妍，速以取勁。先必能速，然後為遲。若素不能速而專事遲，則無神氣；若專務速，又多失勢。

〔十五〕筆勢

下筆之初，有搭鋒者，有折鋒者，其一字之體，定于初下筆。凡作字，第一字多是折鋒，第二、三字承上筆勢，多是搭鋒。若一字之間，右邊多是折鋒，應其左故也

。又有平恕者，如隸畫；藏鋒者，如篆畫。大要折搭多

精神，平藏善含蓄，兼之則妙矣。

〔十六〕情性

藝之至，未始不與精神通，其說見于昌黎《送高閑序》。孫

過庭云：「一時而書，有乖有合，合則流媚，乖則彫疏。

神怡務閑，一合也；感惠徇知，二合也；時和氣潤，三

合也；紙墨相發，四合也。偶然欲書，五合也。心遽體

留，一乖也；意違勢屈，二乖也；風燥日炎，三乖也；

紙墨不稱，四乖也；情怠手闌，五乖也。乖合之際，優

劣互差。」[22]

〔十七〕血脈

字有藏鋒出鋒之異，粲然盈楮，欲其首尾相應，上下相接為佳。後學之士，隨而記憶，善寫其形，未能涵容，皆支離而不相賀字。《黃庭》小楷與《樂毅論》不同，《東方朔[123]畫贊》，又與《蘭亭記》[124]殊旨，一時下筆，各有其勢，固應爾也。余嘗歷觀[125]古之名書，無不點畫振動，[126]如見其揮運之時。山谷云：「字中有筆，如禪句中有眼」。豈欺我哉！[127]

〔十八〕書丹

筆得墨則瘦，得朱則肥。故書丹尤以瘦為奇，而圓勁美潤常有餘，燥勁老古常不足，朱使然也。欲刻者不失真，未有若書丹者。然書時盤薄，不燕火勞。韋仲將升高

書凌雲台榜，下則髭髮已白，藝成而下，斯之謂歟；若鍾繇、李邕，又自刻之，可謂癖矣。

一九九四年六月廿五日摟歷代書法論文選本鈔

充和於美東北港半舫

Textual Variants

The transcribed text is based almost entirely on *Lidai shufa lunwen xuan*, vol. 1, pp. 363–365. We have found this modern critical edition to be the best text available. Textual variants found in five editions are listed below. The editons are abbreviated as follows. Full citations appear in the Bibliography.

歷　歷代書法論文選 *Lidai shufa lunwen xuan*
百　百川學海 *Bai chuan xue hai*
王　王氏書畫苑 *Wang shi shuhua yuan*
佩　佩文齋書畫譜 *Pei wen zhai shuhua pu*
六　六藝之一錄 *Liu yi zhi yi lu*

In 百 and 王, the sections are arranged in this order: 1–8, 18, 16, 17, 9–15.

1　歐陽：歐 (百)
2　西台：李西台 (百，王，六)
3　字：家 (六)
4　書 (百，王)：草 (歷)
5　書 (百，王)：草 (歷)
6　如：抵 (百，王，六)
7　精：兼 (百，王，六)
8　美：妙 (百，王)
9　可：皆可 (百，王)
10　真書：真 (百，王)
11　今：人 (六)
12　神妙：妙 (百，王)
13　書：畫 (百，王)
14　類：頗 (六)
15　魏晉：晉魏 (百，王，六)
16　大小：小大 (百，王，六)
17　少：畫少 (百，王)
18　者：有 (六)
19　惟：專 (百)
20　稍：精 (百，王)
21　人之：人 (百，王)
22　盼：眄 (百，王)
23　體骨：骨體 (百，王，六)
24　乚挑：挑 (百，王)

25　不欲：欲不 (百，王，六)
26　遹：通 (百)
27　故翟：翟 (百，王)
28　何如：如何 (百，王)
29　失：尖 (佩)
30　甚為：甚 (百，王)
31　露則：則 (百，王)
32　藏則：則 (百，王)
33　上大下小：上小下大 (百，王)
34　左高右低：左低右高 (百，王，六)
35　歐陽：歐 (百)
36　太拘：雖太拘 (百，王)；太拘 (六)
37　小：少 (六)
38　也：己 (百)
39　溺于：溺 (百，王)
40　不為書法之無助：不為無助 (百，王)
41　晉魏之：魏晉 (百，王)
42　則埽：埽 (百，王)
43　仿效：仿 (百，王)
44　俗濁不除：俗濁 (百)
45　草書：草 (百，王)

46 右軍：王右軍 (百，王)
47 得字：得字深字 (百，王)
48 章草等：等章草 (百，王)
49 若：若使 (百，王)
50 而未：未 (百，王)
51 規矩最號：最號 (百，王，六)
52 而：而亦 (六)
53 帶則：則 (百，王，六)
54 近俗：近於俗 (百，王，六)
55 代：代之 (百，王)
56 意未盡：意盡 (百，王)
57 折釵股：折釵股者 (百，王)
58 曲：屈 (百，王)
59 屋漏痕：屋漏痕者 (百，王)
60 欲其橫直匀而藏鋒：欲其無起
　 止之跡 (百，王)
61 錐畫沙：錐畫沙者 (百，王)
62 欲其無起止之跡：欲其匀而藏
　 鋒 (百，王)
63 鋒藏：藏鋒 (百，王)
64 明：冥 (百，王)
65 皆：又 (百，王)
66 必有：必 (百，王)
67 如：又如 (百，王)
68 宜：富 (百，王)
69 大抵：大 (百，王)
70 主：知 (百，王)
71 玉：王 (百，王)
72 奉秦：秦奉 (百，王)
73 體：理 (百，王，六)
74 孫過庭：孫氏 (百，王)
75 為：謂 (百，王)
76 長短淺深：深淺長短 (百，王)
77 為：謂 (百，王)
78 為：謂 (百，王)
79 為：謂 (百，王)
80 苟：偶 (百，王)
81 凡作：作 (百，王)

82 墨欲乾：欲乾 (佩) 墨用乾
　 (六)
83 以潤：潤以 (百，王，六)
84 以燥：燥以 (百，王，六)
85 可以取：可以 (百，王)
86 剛而有力：有力 (百，王)
87 緩來：來 (百，王)
88 挺：挺之 (佩)
89 弗：勿 (百，王)
90 弗：不 (百，王)
91 紙：蓋紙 (百，王)
92 草書：草 (百，王)
93 不相遠：苦不相遠 (百，王)
94 柳：楊 (百，王)
95 後世之：後世 (百，王)
96 學：習 (百，王)
97 臨摹：臨 (百，王)
98 亦可：可 (百，王)
99 學書者：學者 (六)
100 用：運 (百，王，六)
101 詳謹：謹詳 (六)
102 大小：小大 (百，王)
103 正：止 (六)
104 或云雙鉤：雙鉤 (六)
105 參：應 (六)
106 顯露：顯顯 (百，王)
107 時參出之：時時一出 (百，
　 王，六)
108 盼：盻 (百，王)
109 右軍蓋為獨步：惟王右軍為妙
　 (百)
110 太巧者：太巧 (百，王)
111 儱等字：儱等 (百，王)
112 在右者皆須：在下右者皆欲
　 (百，王)；在右者皆欲 (六)
113 宀：宀 (百，六)；平 (王)
114 欲：為 (百，王，六)
115 欲：為 (百，王，六)

116 停勻：勻停 (六)

117 筆紙：紙筆 (百，王，六)

118 自然：則自然 (百，王)

119 務：事 (百，王)

120 筆勢：筆鋒 (百，王)

121 心：恐 (百，王，佩)

122 At this point 百 and 王 insert four more quotations from *Shu pu*; see n. 13 of the translation of *Xu shu pu*.

123 東方朔：東方 (百，王)

124 蘭亭記：蘭亭 (百，王，六)

125 余嘗歷觀：予觀 (六)

126 六 inserts here the note 原闕.

127 百 and 王 insert here the words 燥潤見用筆條，勁媚見情性條。

Persons Mentioned

Ban Chao 班超, courtesy name Zhongsheng 仲升 (33–103). Son of the
scholar-historian Ban Biao 班彪 and younger brother of the historiographer
Ban Gu 班固. Spent thirty-one years in the Western Regions (northwest of
modern China proper); was appointed Protector-General of the Western
Regions (*xiyu duhu* 西域都護) and was enfeoffed Marquis of Pacifying Far-
away Lands (*ding yuan hou* 定遠侯).

Bian He 卞和 (eighth–seventh centuries B.C.). "A man in the State of Chu
whose name was He found an uncarved piece of jade in the Chu moun-
tains. He presented it to King Li. King Li ordered a jade expert to appraise
it. The expert said: 'It is just an ordinary stone.' The king considered He a
cheat and ordered that his left foot be cut off. When King Li died, King Wu
ascended the throne. Then He presented his uncarved jade to King Wu.
King Wu ordered a jade expert to appraise it, and the expert said: 'It is just
an ordinary stone.' This king also considered He a cheat and ordered that
his right foot be cut off. When King Wu died and King Wen ascended the
throne, He clasped the uncarved jade in his hands and wept at the foot of
the Chu mountains for three days and three nights. When he had no more
tears, he wept blood. When the king heard about this, he sent a man to ask
him why he wept. The man said to He: 'There are many people in the
world whose feet have been cut off. Why do you weep about it?' He re-
plied: 'I do not lament the loss of my feet. I lament that this precious jade
is labeled an ordinary stone and that an honest man is called a cheat—that
is what I lament.' Thereupon the king ordered a jade expert to evaluate the
uncarved stone, and the expert found it to be precious jade. From then on,
it was called He's jade" (*Han Fei zi*, 4.6b [section 13, "He shi" 和氏]).

Bo Le 伯樂 (seventh century B.C.). An expert judge of horses during the reign
of Duke Mu of Qin 秦穆公 (reigned 659–621 B.C.).

Bo Ya 伯牙. A legendary master player of the qin 琴 (seven-stringed zither)

during the Chunqiu period (722–481 B.C.). His friend Zhong Zi Qi 鍾子期 was his best listener; he always knew what the music being played represented, such as high mountains or a flowing river. When Zhong Zi Qi died, Bo Ya stopped playing the qin.

Cai Yong 蔡邕, courtesy name Bojie 伯喈 (133–192). Prominent man of letters. According to a story told in *Soushen ji*, 13.167 (item 338), Cai Yong, while traveling in Wu 吳, asked to have a piece of parasol-tree wood, which was being burned, removed from the stove because he sensed from the crackling sound that it was a particularly good piece. He then made a qin out of it, which indeed sounded especially fine.

Cao Pi 曹丕, courtesy name Zihuan 子桓 (born winter 187–188, died 226). Reigned from 220 to 226 as first emperor of the Wei dynasty, posthumous title Wendi 文帝. Distinguished poet and writer of prose.

Cao Zhi 曹植, courtesy name Zijian 子建 (192–232). Younger brother of Cao Pi. Distinguished poet and writer of prose.

Chu Suiliang 褚遂良, courtesy name Dengshan 登善 (596-658). High official, scholar, writer, and calligrapher, especially good at li shu.

Confucius 孔子, surname Kong 孔, personal name Qiu 丘, courtesy name Zhongni 仲尼 (551–479 B.C.). The most influential of all Chinese thinkers.

Cui Yuan 崔瑗, courtesy name Ziyu 子玉 (77–142). Scholar, writer, calligrapher.

Ding, Cook 庖丁 (fourth century B.C.). Cook of King Hui of Wei (reigned 369–335 B.C.). According to *Zhuang zi* (chapter 3, "Yang sheng zhu" 養生主), he was marvelously skilled at carving an ox and able to guide his knife in such a way that it never needed sharpening.

Dongfang Shuo 東方朔, courtesy name Manqian 曼倩 (154–93 B.C.). Magician (*fangshi* 方士) and jester (*guji* 滑稽) at the court of Emperor Wu of Han.

Du Du 杜度, courtesy name Bodu 伯度 (first century A.D.). Calligrapher famous for his *cao shu*.

First Emperor of Qin 秦始皇 (260–210 B.C.). Surname Ying 嬴, personal name Zheng 政. Became King of Qin in 247 B.C. and took the title First Emperor after unifying China in 221 B.C.

Fu Jiezi 傅介子 (flourished first half of first century B.C.). Official; ambitious and adventurous explorer. During the Yuanfeng era (80–74 B.C.) he was sent on an embassy to Dayuan 大宛 (modern Ura Tyube in Tajikistan). Upon his return he was enfeoffed Marquis of Yiyang 義陽侯.

Gao Xian 高閑 (ninth century A.D.). Buddhist monk, calligrapher.

Han Yu 韓愈, courtesy name Tuizhi 退之 (768–824). Influential writer, poet,

and Confucian thinker. Because one of the ancestral homes of his family was in Changli 昌黎 (in modern Hebei), he often called himself Han Changli, as did others.

Handan Chun 邯鄲淳, courtesy name Zishu 子淑 (flourished late second and early third centuries). Scholar, author, calligrapher.

Huai Su 懷素, secular surname Qian 錢, courtesy name Cangzhen 藏真 (725–785). Buddhist monk, disciple of Xuan Zang 玄奘. Famous calligrapher.

Huang Tingjian 黃庭堅, courtesy name Luzhi 魯直, aliases Shangu 山谷 and Fuweng 涪翁 (1045–1105). Poet, prose writer, calligrapher.

Huang Xiang 皇象, courtesy name Xiuming 休明 (third century A.D.). Calligrapher in the State of Wu.

Hui, Marquis of Xinyu 新渝惠侯 (fifth or sixth century A.D.). In his eagerness to acquire valuable calligraphic manuscripts, he often fell for forgeries. See Yu He 虞龢 (sixth century A.D.), Lun shu biao 論書表, cited by Zhu Jianxin, p. 125; and Goepper, "Kunstsammler und Sammeln in China," pp. 150–151.

Jiang E 姜噩 (twelfth century). Father of Jiang Kui. District Magistrate (lian ling 縣令) of Hanyang 漢陽 (in modern Hubei Province).

Jiang Kui 姜夔, courtesy name Yaozhang 堯章, alias Baishi daoren 白石道人 (ca. 1155–ca. 1221). Born in Poyang 鄱陽 (in modern Jiangxi Province). Moved to Hanyang 漢陽 (in modern Hubei Province) when he was nine or so years old and stayed there until 1186, when his uncle Xiao Dezao took him to Huzhou 湖州 (modern Wuxing 吳興, in Zhejiang Province). He remained in this area until his death. Writer of both shi 詩 and ci 詞 poetry. Author of Xu shu pu 續書譜 and other prose works; calligrapher. See the Introduction for more details.

Jiang Shu 絳樹 (flourished early third century A.D.). Famous beauty, dancer, and singer. Mentioned by Cao Pi (187 or 188–226) in a letter to Po Qin 繁欽 as an outstanding contemporary dancer; see Quan sanguo wen, 7.3b.

Lao Zi 老子, also called Lao Dan 李聃 and Li Er 李耳. Traditionally considered the founder of philosophical Daoism; putative author of the Daoist classic Dao de jing. Allegedly an older contemporary of Confucius (551–479 B.C.). Dao de jing probably dates from the Warring States period (403–221 B.C.).

Lei, Lady 雷氏 (early fourth century A.D.). A concubine of Wang Dao's, she bore him his second son, Wang Tian, and his third son, Wang Qia.

Li Jianzhong 李建中, courtesy name Dezhong 得中, alias Li Xitai 李西臺 (945–1013). Scholar, official, poet, calligrapher.

Li Yong 李邕, courtesy name Taihe 泰和 (678–747). Official, writer of prose,

calligrapher. The offices he held include Palace Censor of the Left (*zuo tai dian zhong shi yushi* 左台殿中侍御史), Director of the Census Bureau (*hubu langzhong* 戶部郎中), Governor of Ji Commandery (*Ji jun taishou* 汲郡太守), and Governor of Beihai (*Beihai taishou* 北海太守).

Liu Gongquan 柳公權, courtesy name Chengxian 誠懸 (778–865). Scholar, official, poet, calligrapher.

Mi Fu 米芾, courtesy name Yuanzhang 元章, aliases Lumen jushi 鹿門居士, Haiyue waishi 海嶽外史, Xiangyang manshi 襄陽漫士, Mi nangong 米南宮 (1051?–1107). Painter and calligrapher.

Nan(zhi) Wei 南(之)威 (seventh century B.C.). Beauty in the State of Jin during the reign of Duke Wen (reigned 636–627 B.C.).

Ouyang Xun 歐陽詢, courtesy name Xinben 信本 (557–641). Scholar, official, calligrapher. Served as Director of the Court of the Watches (*lei geng ling* 率更令).

Qing Qin 青琴. Goddess, said to be very beautiful.

Sang Hongyang 桑弘羊 (152–80 B.C.). Son of a merchant in Luoyang. Official, scholar. He could do arithmetic calculations in his head, without using an abacus.

Shi Yiguan 師宜官 (flourished second half of second century). Calligrapher during the reign of Emperor Ling (reigned 168–189).

Su Shi 蘇軾, courtesy name Zizhan 子瞻, alias Dongpo 東坡 (1037–1101). Poet, writer of prose, painter, calligrapher.

Sui, Marquis of 隋侯. "The Marquis of Sui . . . on an excursion saw a big snake on the ground in the wilderness; it had been cut into two pieces. He ordered a physician to put it together again. When the snake was cured, it left. Then it came back, holding a large pearl in its mouth as a reward. The pearl was probably a 'bright-moon' pearl. Subsequently it was called the Marquis of Sui's pearl and considered a precious object" (*Huainan zi*, 17.14a, commentary).

Sun Qianli 孫虔禮, courtesy name Guoting 過庭 (born ca. 648, died between 687 and 702). From Wu Commandery 吳郡 or Chenliu 陳留 or Fuyang 富陽. He held the office(s) of Administrative Supervisor of the Guard of the Heir Apparent (*shuaifu lushi canjun* 率府錄事參軍) and/or Administrator of the Helmets Section of the Right Palace Guard (*youwei zhoucao canjun* 右衛胄曹參軍). Author of *Shu pu* 書譜. See the Introduction for more details.

Suo Jing 索靖, courtesy name Youan 幼安 (244?–303). Enfeoffed as Neighborhood Marquis of Anle 安樂亭侯. Calligrapher.

Tang Taizong 唐太宗 (599–649). Surname Li 李, personal name Shimin 世民.

Reigned as second emperor of the Tang dynasty, 626–649. Patron of literature, arts, and music. Fond of calligraphy.

Wang Dao 王導, courtesy name Maohong 茂弘, posthumous title Wenxian gong 文獻公 (276–339). In 307, when north China was overrun by nomadic invaders, he fled south to Jianye 建業 (modern Nanjing) with Sima Rui 司馬睿 and helped him found the Eastern Jin dynasty in 317. Calligrapher, especially good at *xing shu* and *cao shu*.

Wang Hui 王薈, courtesy name Jingwen 敬文 (mid-fourth century A.D.). Sixth and youngest son of Wang Dao. Official.

Wang Meng 王濛, courtesy name Zhongzu 仲祖 (309–347). Good-looking man. Calligrapher, good at *li shu*.

Wang Min 王泯, courtesy name Jiyan 季琰 (351–388). Son of Wang Qia. Held high civil offices. Devout Buddhist; calligrapher, good at *xing shu*.

Wang Qia 王洽, courtesy name Jinghe 敬和 (323–358). Third son of Wang Dao, by Lady Lei. Civil official; devout Buddhist; calligrapher.

Wang Shao 王劭, courtesy name Jinglun 敬倫, posthumous title Jian 簡 (mid-fourth century A.D.). Fifth son of Wang Dao; a handsome and elegant man. High civil and military official; calligrapher.

Wang Tanzhi 王坦之, courtesy name Wendu 文度 (A.D. 330–375). Courtier, official.

Wang Tian 王恬, courtesy name Jingyu 敬預 (314–349). Second son of Wang Dao, by Lady Lei. High military and civil official; distinguished writer of *cao shu* and *li shu*; best chess player in the Eastern Jin Empire.

Wang Xianzhi 王獻之, courtesy name Zijing 子敬 (344–386). Seventh son of Wang Xizhi. Calligrapher. Held the office of Secretariat Director (*zhongshu ling* 中書令), hence sometimes called Great Director Wang (Wang daling 王大令).

Wang Xin 王廞, courtesy name Boyu 伯輿 (died A.D. 397?). Son of Wang Hui. Civil official; calligrapher. Joined Wang Gong 王恭 in his coup attempt against the imperial prince Sima Daozi 司馬道子 in 397, then quarreled with Wang Gong; was presumably killed in 397.

Wang Xiu 王脩, courtesy name Jingren 敬仁 (ca. 335–ca. 358). Eldest son of Wang Meng. Precocious child; famous conversationalist; calligrapher. Friend of Wang Xizhi's.

Wang Xizhi 王羲之, courtesy name Yishao 逸少 (321–379 or 307–365 or 303–361). China's most famous calligrapher. Served as General of the Right Army (*you jun jiangjun* 右軍將軍), hence known as Right-Army Wang (Wang youjun 王右軍).

Wei Dan 韋誕, courtesy name Zhongjiang 仲將 (179–253). Scholar, official, calligrapher.

White Cloud, Master (Baiyun xiansheng 白雲先生), surname and personal name not known. Calligrapher. Contemporary to Wang Xizhi, who wrote the essay "Ji Baiyun xiansheng shu jue" 記白雲先生書訣.

Xi Chao 郗超, courtesy name Jingxing 景興 (flourished second half of fourth century A.D.). Son of Xi Yin. Governor (taishou 太守) of Linhai 臨海; calligrapher, good at cao shu.

Xi Hui 郗恢, courtesy name Daoyin 道胤 (flourished second half of fourth century A.D.). Eldest son of Xi Tan. Military official, calligrapher.

Xi Jian 郗儉, courtesy name Chuyue 處約 (flourished second half of fourth century A.D.). Son of Xi Tan and younger brother of Xi Hui. Director of the Watches in the Household of the Heir Apparent (taizi shuaigeng ling 太子率更令), calligrapher.

Xi Jian 郗鑒, courtesy name Daohui 道徽 (269–339). Younger brother of Xi Hui. Official; calligrapher, good at cao shu.

Xi Tan 郗曇, courtesy name Chongxi 重熙 (flourished fourth century A.D.). Son of Xi Jian 鑒 and younger brother of Xi Yin. Calligrapher.

Xi Yin 郗愔, courtesy name Fanghui 方回 (313–384). Son of Xi Jian 鑒. High civil official; calligrapher, good at zhang cao and li shu.

Xiahou Xuan 夏侯玄, courtesy name Taichu 太初 (209–254). Famous conversationalist. Author of The Eulogy of Yue Yi, which was written out by Wang Xizhi in 348.

Xiahou Zhan 夏侯湛, courtesy name Xiaoruo 孝若 (243–291). Official, poet and writer of prose. Author of The Poem Praising Dongfang Shuo's Portrait, which Wang Xizhi wrote out in 356.

Xiang Ji 項籍, courtesy name Yu 羽 (233–202 B.C.). "Hegemonic king" of Chu and unsuccessful contender for the imperial throne of China after the fall of the Qin dynasty. He was defeated by Liu Bang 劉邦, who founded the Han dynasty.

Xiang Liang 項梁 (died 208 B.C.). Paternal uncle and mentor of Xiang Ji. With Xiang Ji, he took part in the rebellion against the Qin dynasty, and he was defeated by the Qin army.

Xiao Dezao 蕭德藻 (flourished 1186). Maternal uncle of Jiang Kui. Official, scholar, poet.

Xiao Ziyun 蕭子雲, courtesy name Jingqiao 景喬 (487–549). Member of the imperial family of the Southern Qi dynasty, high official under the Liang dynasty, historiographer, calligrapher.

Xie An 謝安, courtesy name Anshi 安石, posthumous title Grand Master (*taifu* 太傅) (320–385). High official, calligrapher.

Xie Shang 謝尚, courtesy name Renzu 仁祖, posthumous title Jian 簡 (308–357). Elder cousin of Xie An. Child prodigy. Held high civil and military offices. Skillful musician, calligrapher.

Xie Yi 謝奕, courtesy name Wuyi 無奕 (born before 320, died 358). Elder brother of Xie An. Held high civil and military offices. Calligrapher.

Xu Hao 徐浩, courtesy name Jihai 季海, posthumous title Ding 定, also called Xu Kuaiji 徐會稽 (703–782). Official, writer of prose, calligrapher.

Xu Yan 徐偃 (late eleventh–early tenth centuries B.C.). Maker of writing brushes, mentioned in Tang Taizong's postscript to the biography of Wang Xizhi (*Jin shu*, 80.2108).

Xuan Yuan 軒轅, also called Huang Di 黃帝. Legendary ruler during remote antiquity.

Yan Hui 顔回, courtesy name Ziyuan 子淵 (521–490 B.C.). Disciple of Confucius.

Yan Zhenqing 顔真卿, courtesy name Qingchen 清臣 (709–785). Official, scholar, lexicographer, calligrapher.

Yang Xin 羊欣, courtesy name Jingyuan 敬元 (370–442). Official; medical expert; calligrapher.

Yang Xiong 揚雄, courtesy name Ziyun 子雲 (53 B.C.–A.D. 18). Court poet, writer of *fu* poetry, philosopher.

Yang Xiu 楊脩, courtesy name Dezu 德祖 (175–219). Official; man of letters; friend of Cao Zhi's.

Yu Liang 庾亮, courtesy name Yuangui 元規 (289–340). Eldest brother of Empress Mu, consort of the Jin emperor Ming (reigned 323–325). Handsome, eloquent man; high military and civil official; calligrapher, good at *cao shu*.

Yu Shinan 虞世南, courtesy name Boshi 伯施, posthumous title Wenyi 文懿 (558–638). Scholar, offficial, writer of prose, calligrapher.

Yu Xi 庾羲, courtesy name Shuhe 叔和 (flourished mid-fourth century A.D.). Third son of Yu Liang. Official.

Yu Yi 庾懌, courtesy name Shuyu 叔預, posthumous title Jian 簡 (293–342). Civil and military official; calligrapher.

Yu Yi 庾翼, courtesy name Zhigong 稚恭 (305–345). Younger brother of Yu Liang and of Empress Mu, consort of the Jin emperor Ming (reigned 323–325). High military and civil official; calligrapher, good at *cao shu* and *li shu*.

Yu Zhun 庾準, courtesy name Yanzu 彥祖 (flourished second half of fourth century A.D.). Son of Yu Xi. Civil and military official; calligrapher.

Yue Yi 樂毅 (fourth to third centuries B.C.) Military genius. Served the State of Yan 燕 under King Zhao 昭 (reigned 311–279 B.C.). Defeated Qi 齊 and was enfeoffed Lord of Changguo 昌國君. After King Zhao's death, King Hui 惠 (reigned 278–271 B.C.) suspected him of disloyalty. Yue Yi fled to Zhao 趙, where he was enfeoffed as Wang zhu jun 望諸君. Later, the State of Yan rehabilitated and recalled him. He died in Zhao.

Zeng Shen 曾參, courtesy name Ziyu 子輿, also called Master Zeng 曾子 (505–435 B.C.). Disciple of Confucius.

Zhai Qinian 翟耆年, courtesy name Boshou 伯壽, alias Huanghe shanren 黃鶴山人. Son of Zhai Ruwen 汝文 (1076–1141). Scholar, official.

Zhang Huaiguan 張懷瓘 (eighth century). During the Kaiyuan era (713–742) he rose to the position of Hanlin Academician for Court Service (hanlin yuan gongfeng 翰林院供奉). Calligrapher, good at zhen shu, xing shu, cao shu, small zhuan shu, and ba fen. Author of works on calligraphy.

Zhang Qian 張騫 (second century B.C.). Expert on central Asia. In 139 B.C., when he was a young man, he was sent as an envoy to the Yuezhi 月氏 in order to work out an alliance between the Han Empire and the Yuezhi against the Xiongnu 匈奴. En route he was captured by the Xiongnu; he settled in their country, took a Xiongnu wife, and raised a family, living there for more than ten years but remaining loyal to Han China. He escaped from the Xiongnu and reached the Yuezhi in what is now northern Pakistan. But the Yuezhi had no interest in an alliance with China. As he was returning home, he was captured again by the Xiongnu. He finally reached Chang'an (modern Xi'an), the Western Han capital, in 126. He provided the court with valuable information on central Asia. Later he fought in several campaigns against the Xiongnu and others, putting his knowledge of terrain and customs to good use. He did much to enhance Chinese power and influence in central Asia and to increase trade in both directions. He was enfeoffed Marquis of Farsighted Providence (bowang hou 博望侯).

Zhang Xu 張旭, courtesy name Bogao 伯高, also called Administrator Zhang (Zhang zhangshi 張長史), Upside-Down Zhang (Zhang dian 張顛), Sage of cao (cao sheng 草聖) (flourished second half of eighth century A.D.). Official, calligrapher, drunkard.

Zhang Yanyuan 張彥遠, courtesy name Aibin 愛賓 (ninth century A.D.). Official; author of Fa shu yaolu, a work on calligraphy.

Zhang Zhi 張芝, courtesy name Boying 伯英, alias Youdao 有道, also called Sage of *cao* (cao sheng 草聖) (died ca. A.D. 192). Calligrapher.

Zhi Yong 智永, surname Wang 王, alias Yong chanshi 永禪師 (flourished early seventh century A.D.). Buddhist monk, calligrapher.

Zhong You 鍾繇, courtesy name Yuanchang 元常 (151–230). Official, calligrapher.

Zhuang Zi 莊子, surname Zhuang, personal name Zhou 周 (ca. 369–ca. 286 B.C.). Daoist philosopher. Putative author of the Daoist work bearing his name, which is believed to have been written in increments from the third century B.C. to the third century A.D.

Zi Gao, Duke of She 葉公子高 (sixth–fifth centuries B.C.?). High minister of Chu, member of the royal family of Chu, contemporary of Confucius. "Zi Gao, Duke of She, liked dragons. He sketched dragons, sculpted dragons, and carved dragons in his house. A dragon heard about this and came to take a look. Its head was at the window, and it dragged its tail in the hall. When the Duke of She saw it, he ran away, losing his senses. Thus the Duke of She did not really like dragons; he liked things that looked like dragons but were not real dragons" (Xin xu, 5.14a-b [section 5, "Zashi" 雜事]).

Glossary of Calligraphic Terms

ba fen 八分. A variant of *li shu*.

bi che 壁坼. "Cracks in a wall," vertical downward strokes with natural zigzag turns.

bo 波. "Wave," a wavy line moving more horizontally than vertically.

cao (shu) 草(書). Cursive script. An example is Sun's *Shu pu* autograph, reproduced in this book.

chong (zhuan) 虫(篆). "Wiggly-worm seal script."

chui lu 垂露. "Hanging dewdrop," a vertical downward stroke ending with a rounded point.

fei bai 飛白. "Flying white," a stroke done with a half-dry brush, leaving black streaks instead of solid black.

fu ㇏. Curving line moving from the upper left to the lower right.

kai (shu) 楷(書). Regular script, standard script. Also called *zheng shu* or *zhen shu*.

li (shu) 隸(書). Official script, clerical script.

na ㇏. Stroke moving from the upper left to the lower right, slightly curved, like a flattened letter S.

pie ノ. Stroke moving from the upper right to the lower left.

tiao ti 挑剔. Stroke moving down vertically, then to the right horizontally, then straight up, like this: ㇄.

wu lou hen 屋漏痕. "Traces of a leaky roof," vertical, slightly wriggly downward stroke.

xing (shu) 行(書). Running script, closer to *kai shu* than to *cao shu*.

xuan zhen 懸針. "Suspended needle," vertical downward stroke ending in a sharp point.

zhang (cao) 章(草). Draft cursive script. There are several conflicting explanations of the origin of this term.

zhe chai gu 折釵股. "Bent hairpin," a strong turn with a round curve.

zhen (shu) 真(書). Regular script, standard script. Also called *kai shu* or *zheng shu*.

zheng shu 正書. Regular script, standard script. Also called *kai shu* or *zhen shu*.

zhuan (shu) 篆 (書) . Seal script. A distinction is made between greater and lesser *zhuan*; "greater *zhuan*" refers to seal script before the Qin dynasty, and "lesser *zhuan*" to seal script from the time of the First Emperor of Qin on.

zhui hua sha 錐畫沙. "Lines drawn by an awl in the sand," strokes done with a concealed brush tip, like impressions made by a seal in mud.

Bibliography

Chinese works written before 1900 are listed by title; Chinese works written after 1900 are listed by author; works in languages other than Chinese are listed by author; and anonymous works in any language are listed by title.

Ba jue 八訣. By Ouyang Xun 歐陽詢 (557–641). In *Lidai shufa lunwen xuan*, vol. 1, pp. 98–99.

Bai bu congshu jicheng 百部叢書集成. Taipei: Yiwen 藝文, 1965.

Bai chuan xue hai 百川學海. In *Bai bu congshu jicheng*.

Barnhart, Richard M. "Wei Fu-jen's Pi Chen T'u and the Early Texts on Calligraphy." *Archives of the Chinese Art Society of America* 18 (1964), 13–25.

Bi zhen tu 筆陣圖. Attributed to Wei Shuo 衛鑠 (272–349). In *Lidai shufa lunwen xuan*, vol. 1, pp. 21–23. [For a discussion of this work, see Barnhart.]

Bischoff, Friedrich A. *The Songs of the Orchis Tower*. Wiesbaden: Harrassowitz, 1985.

Cao shu Qian zi wen 草書千字文. [Allegedly reproduces the handwriting of Sun Qianli.] Two versions in *Shoseki meihin sokan* 書跡名品叢刊. Tokyo: Nigensha 二玄社, 1976.

Cao Zhi ji jiaozhu 曹植集校注 (Collected Works of Cao Zhi [192–232]). Ed. Zhao Youwen 趙幼文. Beijing: Renmin wenxue 人民文學, 1984.

Chang, Léon Long-yien, and Peter Miller. *Four Thousand Years of Chinese Calligraphy*. Chicago: University of Chicago Press, 1990.

Chen Zi'ang ji 陳子昂集 (Collected Works of Chen Zi'ang [661–702]). Ed. Xu Peng 徐鵬. Shanghai: Zhonghua 中華, 1960.

Chu ci 楚辭 (Songs of the South). In *Chu ci duben* 楚辭讀本, annotated by Fu Xiren 傅錫壬. Taipei: Sanmin shuju 三民書局, 1984.

Dao de jing 道德經. [Daoist classic attributed to Lao Zi but now believed to date back only to the Warring States period (403–221 B.C.).] In *Si bu congkan*.

"Diao fu" 釣賦. By Pan Ni 潘尼 (ca. 248–ca. 310). *Quan Jin wen*, 94.2b.

Fa shu yaolu 法書要錄. By Zhang Yanyuan 張彥遠 (ninth century A.D.). In *Wang shi shuhua yuan*.

Fa yan 法言. By Yang Xiong 揚雄 (53 B.C.–A.D. 18). In *Si bu congkan*.

Fu, Shen C. Y. *Traces of the Brush: Studies in Chinese Calligraphy*. New Haven: Yale University Art Gallery, 1977.

Fu, Shen C. Y., and Marilyn Fu. *Studies in Connoisseurship*. Princeton: Princeton University Press, 1973.

Goepper, Roger. *The Essence of Chinese Painting*. Trans. Michael Bullock. London: Lund Humphries, 1963. Original German title: *Das Wesen der chinesischen Malerei*.]

————. "Kunstsammler und Sammeln in China." *Jahrbuch Preußischer Kulturbesitz* 8 (1970), 149–161.

————. *Shu-p'u, der Traktat zur Schriftkunst des Sun Kuo-t'ing*. Wiesbaden: Franz Steiner, 1974.

Grube, Wilhelm. *Geschichte der chinesischen Litteratur*. Leipzig: Amelang, 1909.

Gulik, Robert Hans van. *Chinese Pictorial Art as Viewed by the Connoisseur*. Serie Orientale Roma 19. Rome: Istituto Italiano per il Medio ed. Estremo Oriente, 1958.

Han Fei zi 韓非子. By Han Fei (died 233 B.C.). In *Si bu congkan*.

Holzman, Donald. Review of Bischoff, *Songs of the Orchis Tower*. In *Orientalistische Literaturzeitung* 83 (1988), 487–489.

Hou Han shu 後漢書 (History of the Later Han Dynasty [A.D. 25–220]). By Fan Ye 范曄 (398–445). Beijing: Zhonghua 中華, 1973.

Huainan zi 淮南子. [Written in the second century B.C. by guests at the court of Liu An 劉安, Prince of Huainan, who committed suicide in 122 B.C.] In *Si bu congkan*.

Hucker, Charles O. *A Dictionary of Official Titles in Imperial China*. Stanford: Stanford University Press, 1985.

The I Ching or Book of Changes. 3d ed. Trans. Cary F. Baynes. Bollingen Series 19. Princeton: Princeton University Press, 1969. [English translation of Richard Wilhelm's German translation of Yi jing.]

Jin shu 晉書 (History of the Jin Dynasty [266–420]). Comp. Fang Xuanling 房玄齡 (578–648) and others. Beijing: Zhonghua 中華, 1974.

Jiu Tang shu 舊唐書 (Old History of the Tang Dynasty [618–907]). Comp. Liu Xu 劉昫 (887–946) and others. Beijing: Zhonghua 中華, 1975.

Liang Piyun 梁披雲 and others, comps. *Zhongguo shufa da cidian* 中國書法大辭典. 2 vols. Hong Kong: Shu Pu Publishing Co. 書譜出版社, 1984.

Lidai shufa lunwen xuan 歷代書法論文選. 2 vols. Shanghai: Shanghai shuhua chubanshe 上海書畫出版社, 1979.

Lin, Shuen-fu. "Chiang K'uei." In *The Indiana Companion to Traditional Chinese Literature*, ed. William H. Nienhauser, Jr. Bloomington: Indiana University Press, 1986, pp. 262–264.

———. "Chiang K'uei's Treatises on Poetry and Calligraphy." In *Theories of the Arts in China*, ed. Susan Bush and Christian Murck. Princeton: Princeton University Press, 1983, pp. 293–314.

———. *The Transformation of the Chinese Lyrical Tradition: Chiang K'uei and Southern Sung Tz'u Poetry*. Princeton: Princeton University Press, 1978.

Liu yi zhi yi lu 六藝之一錄. Ed. Ni Tao 倪濤 (Qing dynasty). In *Si ku quan shu zhen ben chu bian* 四庫全書珍本初編. Shanghai: Shangwu 商務, 1935.

Lun shu 論書. By Huang Tingjian 黃庭堅 (1045–1105). In *Lidai shufa lunwen xuan*, vol. 1, pp. 353–357. [Not to be confused with Yu Yuanwei's Lun shu.]

Lun shu 論書. By Yu Yuanwei 庾元威 (Liang dynasty, sixth century). In *Quan Liang wen*, 67.10a–13a. [Not to be confused with Huang Tingjian's Lun shu.]

Lun shu biao 論書表. By Yu He 虞龢 (flourished 470). In *Lidai shufa lunwen xuan*, vol. 1, pp. 49–55. Lun shu biao is dated 470.

Lun yu 論語 (The Analects of Confucius). In *A Concordance to the Analects of Confucius*. Harvard–Yenching Institute Sinological Index Series, Supplement no. 16. Beijing, 1940.

Margouliès, Georges. *Anthologie raisonnée de la littérature chinoise*. Paris: Payot, 1948.

Mo sou 墨藪. Attributed to Wei Xu 韋續 (Tang dynasty). In *Yishu congbian* 藝術叢編. Taipei: Yiwen 藝文, 1965.

Pei wen zhai shuhua pu 佩文齋書畫譜. Ed. Wang Yuanqi 王原祁 and others. Preface dated 1708.

Qi Gong 啟功. "Sun Guoting Shu pu kao" 孫過庭書譜攷. In *Qi Gong cong gao* 啟功叢稿. Beijing: Zhonghua, 1981, pp. 60–89. [Dated 1964; originally published in *Wen wu* 文物, 1964.2, 19–33.]

Quan Jin wen 全晉文. In *Quan shanggu sandai Qin Han sanguo liuchao wen*.

Quan Liang wen 全梁文. In *Quan shanggu sandai Qin Han sanguo liuchao wen*.

Quan sanguo wen 全三國文. In *Quan shanggu sandai Qin Han sanguo liuchao wen*.

Quan shanggu sandai Qin Han sanguo liuchao wen 全上古三代秦漢三國六朝文. Comp. Yan Kejun 嚴可均 (1762–1843). Beijing: Zhonghua 中華, 1958.

Shi Huai Su yu Yan Zhenqing lun cao shu 釋懷素與顏真卿論草書. By Lu Yu 陸羽 (733–804). In *Lidai shufa lunwen xuan*, vol. 1, p. 283.

Shi ji 史記. By Sima Qian 司馬遷 (ca. 145–ca. 85 B.C.). Beijing: Zhonghua 中華, 1972.

Shi jing 詩經 (Classic of Songs). [The oldest collection of Chinese poetry; one of the Confucian Classics.] In *A Concordance to Shih Ching*. Harvard–Yenching Institute Sinological Index Series, Supplement no. 9. Beijing, 1934.

Shi shuo xin yu 世說新語. Comp. Liu Yiqing 劉義慶 (403–444). In Shi shuo xin yu jiao jian 世說新語校箋, ed. Yang Yong 楊勇. Hong Kong: Da zhong shuju 大眾書局, 1969. [For a translation, see Shih-shuo Hsin-yü.]

Shih-shuo Hsin-yü: A New Account of Tales of the World. By Liu I-ch'ing with commentary by Liu Chün. Trans. Richard B. Mather, Minneapolis: University of Minnesota Press, 1976.

Sho fu 書譜. Ed. Nishibayashi Shōichi 西林昭一. Tokyo: Meitoku Shuppansha 明德出版社, 1972.

Shu duan 書斷. By Zhang Huaiguan 張懷瓘 (eighth century). In Lidai shufa lunwen xuan, vol. 1, pp. 156–208.

Shu gu 書估. By Zhang Huaiguan 張懷瓘 (eighth century). In Lidai shufa lunwen xuan, vol. 1, pp. 150–153.

Shu jing 書經 (Classic of Documents), also called Shang shu 尚書. [One of the Confucian Classics.] In Shang shu tong jian 尚書通檢, ed. Gu Jiegang 顧頡剛. Beijing: Harvard–Yenching Institute, 1936.

Shu shu fu 述書賦. By Dou Ji 竇臮 (flourished mid-eighth century A.D.). With commentary by his elder brother Dou Meng 竇蒙. In Lidai shufa lunwen xuan, vol. 1, pp. 236–268.

Shu Zhang zhangshi bifa shi'er yi 述張長史筆法十二意. By Yan Zhenqing 顏真卿 (709–785). In Lidai shufa lunwen xuan, vol. 1, pp. 277–280.

Shuo wen jie zi 說文解字. By Xu Shen 許慎 (30–124). In Si bu congkan.

Si bu congkan 四部叢刊. Shanghai: Commercial Press, 1919–1936.

Si ti shu shi 四體書勢. By Wei Heng 衛恆 (died A.D. 291). In Lidai shufa lunwen xuan, vol. 1, pp. 11–17.

Song Gao Xian shangren xu 送高閑上人序. By Han Yu 韓愈 (768–824). In Zhu wengong jiao Changli xiansheng ji 朱文公校昌黎先生集 (in Si bu congkan), 21.2a–3a. Also in Lidai shufa lunwen xuan, vol. 1, pp. 291–292.

Soushen ji 搜神記. By Gan Bao 干寶 (flourished A.D. 320). Ed. Wang Shaoying 汪紹楹. Beijing: Zhonghua 中華, 1979.

Sun Guoting Jingfu dian fu 孫過庭景福殿賦. By He Yan 何晏; calligraphy attributed to Sun Qianli. Shanghai: Shanghai wenwu chubanshe 上海文物出版社, 1976.

Sun Guoting Shu pu jinzhu jinyi 孫過庭書譜今註今譯. Ed. and trans. Yao Ping 姚平. Taipei: Zhengzhong shuju 正中書局, 1981.

Sun Guoting Shu pu yi zhu 孫過庭書譜譯註. Ed. and trans. Ma Guoquan 馬國權. Taipei: Ming Wen Book Co. 明文書局, 1984.

Sun Ta-yü 孫大雨. "On the Fine Art of Chinese Calligraphy by Sun Kuo-t'ing of the T'ang Dynasty, Freely Rendered into English by Sun Ta-yü." T'ien Hsia Monthly 1 (September 1935), 192–207.

Tseng Yuho. *A History of Chinese Calligraphy*. Hong Kong: Chinese University Press, 1993.

Wang Gang 王崗 and Xiao Yun 肖云. "Sun Guoting de yiyi: Chu Tang shufa meixue xunli" 孫過庭的意義—初唐書法美學巡禮. In *Shufa yanjiu* 書法研究, no. 1 (1987), 27–55.

Wang shi shuhua yuan 王氏書畫苑. Comp. Wang Shizhen 王世貞 (1526–1590). Reprint Shanghai: Taidong tushu ju 泰東圖書局, 1922.

Wen fu 文賦. By Lu Ji 陸機 (261–303). In *Essay on Literature*, by Lu Chi; trans. Shih-Hsiang Chen. Portland, Me.: Anthoensen Press, 1953.

Wilhelm, Richard. *Die chinesische Literatur*. Wildpark-Potsdam: Athenaion, 1926.

Xin xu 新序. By Liu Xiang 劉向 (ca. 79–ca. 6 B.C.). In *Si bu congkan*.

Xu Bangda 徐邦達. "Sun Guoting zi Qianli, Sun Qianli zi Guoting shi fou yi ren zhiyi" 孫過庭字虔禮孫虔禮字過庭是否一人質問. In his *Lidai shuhuajia zhuanji kaobian* 歷代書畫家傳記攷辨. Shanghai: Shanghai Renmin meishu chubanshe 上海人民美術出版社, 1983, pp. 6–9.

Xuanhe shu pu 宣和書譜. (Song dynasty). Shanghai: Shanghai shuhua chubanshe 上海書畫出版社, 1984.

Yi jing 易經 (Classic of Changes). [One of the Confucian Classics.] In *A Concordance to Yi Ching*. Harvard–Yenching Institute Sinological Index Series, Supplement no. 10. Beijing; 1935. [For an English translation, see *I Ching*, trans. Baynes.]

Zhu Jianxin 朱建新, ed. *Sun Guoting Shu pu jianzheng* 孫過庭書譜箋証. Shanghai: Shanghai guji chubanshe 上海古籍出版社, 1982.

Zhuang Zi. *The Complete Works of Chuang Tzu*. Trans. Burton Watson. New York: Columbia University Prtess, 1968.

Zhuang zi 莊子. Attributed to Zhuang Zhou 莊周 (ca. 369–ca. 286 B.C.). [Believed to consist of many layers, dating from the third century B.C. to the third century A.D.] In *A Concordance to Chuang Tzu*, Harvard–Yenching Institute Sinological Index Series, Supplement no. 20. Beijing, 1947. [For an English translation, see Zhuang Zi, *Complete Works*, trans. Watson.]

Index